Shoreham and Wading River

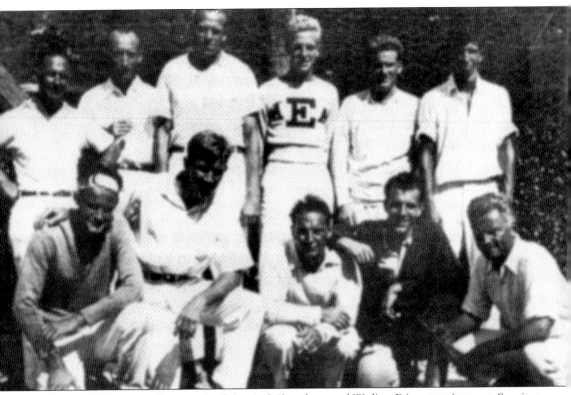

This is a 1932 group photograph of the rival Shoreham and Wading River tennis teams. Starting eight years earlier, in 1924, and continuing to this day, this intense competition between friendly neighbors began what is now reputedly the longest continuous tennis series in the United States, always played Labor Day Weekend before enthusiastic crowds. Initially limited to men, women's matches became a regular part of the competition in 1978. (Shoreham Village Archives.)

ON THE FRONT COVER: Postmarked 1910, this postcard is typical of the many beach scenes found on postcards for Wading River. The Wading River community has had a centuries-long association with the beach and Long Island Sound—for commerce, food, recreation, and sport. (Jane Alcorn Collection.)

ON THE BACK COVER: The distinctive gambrel-roofed Shoreham Store was built in 1910 by Shoreham developer Herbert Hapgood. It was a general store that was a great convenience to generations of Shorehamites, as well as a popular meeting place where locals could chat about their golf scores, village affairs, or the weather. Still a local landmark, it became a private residence in the 1980s after a long succession of owners and guises, ending its commercial life as a delicatessen. (Mary Ann Oberdorf Collection.)

POSTCARD HISTORY SERIES

Shoreham and Wading River

Jane Alcorn and Mary Ann Oberdorf

ARCADIA
PUBLISHING

Published by Arcadia Publishing
Charleston, South Carolina

Printed in the United States of America

Library of Congress Control Number: c

For all general information contact Arcadia Publishing at:
Telephone 843-853-2070
Fax 843-853-0044
E-mail sales@arcadiapublishing.com
For customer service and orders:
Toll-Free 1-888-313-2665

Visit us on the Internet at www.arcadiapublishing.com

Dedicated to our husbands, Bob Alcorn and Joe Falco, who patiently endure our collections, questions, requests for assistance, and passion for history.

Contents

ACKNOWLEDGMENTS

Jane Alcorn would like to thank Carol and William Eibs (CE) for access to their extensive family collection of postcards, photographs, and documents and for sharing their knowledge and enthusiasm; to J. Lance and Maryalyce Johnsen (LJ) for their gracious assistance and the use of their postcard collection; to Jane Danby, Tom Miller, and Irvin Meier for sharing their knowledge of old Wading River; and to the Wading River Historical Society (WRHS) for use of its collection and for its support.

Mary Ann Oberdorf would like to first thank Louise Bellport (LB) for her most generous sharing of her extensive early postcard collection of Shoreham Village. Also, special thanks to Kenneth Brady (KB), historian of Port Jefferson Village, for his enthusiasm, knowledge, encouragement, and support over many years. Thanks to Coline Jenkins (CJ), great-great granddaughter of Elizabeth Cady Stanton, whom the author first met in Seneca Falls, New York, in 2008 at the 160th anniversary of the First Women's Rights Convention. Jenkins immediately recognized the name "Shoreham" and very graciously offered to share early family photographs. Many thanks to Linda Garvin Kallenbach (LGK) for her donation of copies of early family photographs to the Village archives. Shoreham's archives would be sparse indeed if Peter and Katherine ("Kay") Pallister Spier had not returned to Kay's beloved Shoreham in 1967. As Shoreham Village historian from 1986 to 2010, Peter acquired, organized, and catalogued a wonderful collection of photographs, documents, old Village publications, artifacts, and historical accounts.

Both authors would like to thank Kathryn Curran, Edward "Ned" Smith, and Wallace Broege of the Suffolk County Historical Society (SUFFOLKCOHISSOC) and Erik Huber at the Queens Borough Public Library (QBPL) for access and permission to use photographs from their Long Island Collections. And finally, a very warm thank-you to Erin Rocha and Abby Henry at Arcadia Publishing, whose encouragement and support made this book possible.

The abbreviations that appear in the courtesy lines for the images in this volume correspond to the following sources:

Carol and William Eibs Collection (CE)
Coline Jenkins/Elizabeth Cady Stanton Trust (CJ)
Jane Alcorn Collection (JA)
Kenneth Brady Collection (KB)
Louise Bellport Collection (LB)
J. Lance and Maryalyce Johnsen Collection (LJ)
Linda Garvin Kallenbach Collection (LGK)
Mary Ann Oberdorf Collection (MAO)
Suffolk County Historical Society (SUFFOLKCOHISSOC)
Shoreham Village Archives (SVA)
Wading River Historical Society (WRHS)

INTRODUCTION

Shoreham and Wading River are two friendly neighbors that share a common heritage.

Wading River has been a wonderful place for people to live since prehistoric times. Initially home to Paleo-Indians over 5,000 years ago, its most recent indigenous people called the area Pauquaconsuck. This name is loosely translated as "place where we wade for thick, round-shelled clams." The Corchaug people lived from Wading River east to Orient Point and the Setalcott people from Setauket to Wading River. These early inhabitants existed with nature and used the bounty of the sea and forest. They also kept gardens where squash, beans, and corn–known as the Three Sisters—were grown. They hunted, fished, and gathered wild berries and other plants they knew were good for their health. They also maintained an industry, providing the clam and periwinkle shells from which wampum was made. Long Island was called the "Klondike of the Algonquians" for these shells, and it is a matter of early records that the Indians of the Hudson River, New England, and the rest of Long Island obtained much of their wampum from Wading River.

When white people settled in the area in 1671, they were drawn by the availability of fresh water, woods filled with game, and the nearness of Long Island Sound, much as earlier inhabitants had been. Called North Sea by these first white men, its tidal action, transportation possibilities, and marine resources attracted their attention, as did the potential for farming and the harvest of abundant cordwood.

The Town of Brookhaven first decreed on November 17, 1671, that permission was granted for a "settlement of eight families or eight men, at the Wading River." References to Wading River in earlier documents are believed to be about the waterway itself, rather than any settlement in the area.

The families came. From the west, Daniel Lane Jr. from Setauket arrived, who was given "a lotment at the Wading River convenient to the water for his calling." Along with Lane, other settlers came, with names still familiar to locals today. From the east, prior to 1680, a contingent of about 30 more settlers arrived from Southold, including John Harod, whose name lives on in Herod's Point. John Howell, Daniel Terry, David Horton, Benjamin Youngs, and Richard Youngs were among the settlers whose names still adorn streets and landings in the region. Southold residents called the community Westholde, reflecting its western location in relation to Southold, although the Brookhaven residents also used the names Red Creek or Red Brook.

Within a month after the arrival of the first settlers, Brookhaven town records indicate provision for a mill. Built by Henry Perring (Perin), it was situated near the land of Richard Woodhull, holder of the first land patent in the area, and later came into the possession of a Mr. Woolley. The house on Woodhull's land was built by his grandson Josiah Woodhull around 1675 and remains the oldest house still standing in Wading River. The second mill was built in 1708 by John Roe at the Mill Pond and operated for almost 200 years. There were eventually three mills in Wading River. A gristmill was operated by the aforementioned Daniel Lane, Jr., who had worked with his father as a miller in Setauket. A log mill is known to have been in the community from a discovery of large deposits of buried sawdust near its location.

A part of the new village's industries was a tannery, which was built before 1710 near Woolley's Mill. A blacksmith eventually set up shop, and a wheelwright established his business on what is now North Country Road. Along with those businesses, eventually the village could also claim a cider mill near what are now the Duck Ponds, a candy factory, a shoemaker, and a cutlery shop. There were also two shipyards—one near the public beach, called the East Landing, and the other at the West Landing, which was closer to the creek. The stalwart, determined people persevered to keep the community growing.

In 1895, the Long Island Railroad extended its North Shore Branch to Wading River. This made it possible for more people to travel easily from New York City and other western Long Island locations to the shore community. The railroad promoted the area as a good place to farm by sponsoring LIRR Experimental Farm No. 1, a showplace of a fertile garden and farm developed by Hal B. and Edith Fullerton.

The community grew and became a vacation spot, with people enjoying the water for sport and food and the area's farms providing fresh produce. Parks and camps were created for recreation. Scout groups, church groups, and New York State all developed campgrounds in Wading River.

Today, Wading River is part of two towns. The area west of the creek is still in Brookhaven, while the eastern section is now a part of the Town of Riverhead, which came into being when Southold ceded the western part to a new town in March of 1792. The community today boasts many more people and many more businesses, and the mills no longer exist, the businesses are different, and the town is much larger.

Some things have not changed, however. People still are attracted to the area by its location near the Long Island Sound and come for summer vacations. Others take day trips to pick pumpkins, strawberries, tomatoes, or other produce fresh from the fields and enjoy the sights, sounds, and bounty of the region. Still others come to camp at the area's parks and campgrounds.

Shoreham developed later than its shorefront neighbor to the east, Wading River, because it lacked a harbor or inlet. Back in the 17th century, it lay in the wilderness between the east-end settlements of the New Englanders and the west-end settlements of the Dutch and the English who followed.

A small community first developed at Shoreham around the mid-1700s at the north end of what is now Woodville Road, where a break in the bluffs, or a landing, allowed easy access to the beach. It was originally known as Swezey's Landing, named after Daniel Swezey, who ran a store that stood until 2005 on the corner of what is now Woodville and Gridley. It was renamed Woodville Landing around 1840 for the wood-cutting business that had developed in the area. Woodchoppers cut cordwood from stands of timber and then hauled it to the beach along Woodville Road by horse and wagon. At low tide, the cordwood was loaded onto shallow-hulled boats for transport to New York City and to the brick kilns at Haverstraw on the Hudson.

With the extension of the Long Island Railroad's Port Jefferson line to Woodville Landing and Wading River in 1895, the area was suddenly ripe for development. In 1894, Woodville Landing's first developer, James Warden, purchased three farms totaling about 2,000 acres. He renamed the settlement Wardenclyffe and in the summer of 1900, he opened a summer resort and colony featuring the Wardenclyffe Inn at the corner of Woodville and Briarcliff roads. The resort included a bathing beach with a bathing pavilion built right into the face of the bluff. It lasted 20 years and then collapsed due to erosion. A handful of cottages were built as well as recreational facilities, including tennis and croquet courts. The resort colony grew much of its own food. Warden hired a horticulturist to cultivate an orchard of apples and peaches on the site of the present-day tennis courts and ball field, and there were also vegetable gardens. He also established a store, and an ice house and fruit cellar, now a private residence just east of the modern-day platform tennis courts.

Prominent early residents of Wardenclyffe included famous playwright and theater critic Channing Pollack and two leaders in the women's suffrage movement Elizabeth Cady Stanton, national co-chair and speechwriter for Susan B. Anthony, and her daughter Harriett Stanton Blatch, who led the successful New York suffrage movement. It was Warden who lured the great electrical

engineer and inventor Nikola Tesla to establish his experimental laboratory near the Wardenclyffe train station. There, with the backing of financier J.P. Morgan, Tesla erected a beautiful brick laboratory designed by the famous New York architect Stanford White, as well as a 187-foot tower for experiments on the long-distance transmission of radio waves and electricity. The project was short-lived, however, as Morgan withdrew his backing after Marconi beat Tesla in making a successful transatlantic radio transmission. The tower was demolished, but the laboratory building remains, and there are plans for a Tesla museum at the site.

When Warden died in 1906, partner and co-executor Herbert Hapgood took over development of Wardenclyffe. Between 1906 and 1910, he built a community of 50 summer cottages up the hill on the west side of Woodville. With partners Henry B. Johnson and Richard D. Upham, he built several grand estates on large lots along the hilltops east of Woodville on Tower Hill and Briarcliff Roads. Thanks to the woodchoppers, the land was open and most homes had water views. They were built in the simple American Foursquare style of the Arts and Crafts movement. Around 1910, Upham's wife, Elizabeth, renamed Wardenclyffe to Shoreham after Shoreham-by-the-Sea, England. Shoreham was incorporated as a village in 1913 so that the community could raise a bond for the paving of its roads. Claude V. Pallister was elected its first president (the office was later renamed as mayor).

The new summer residents—doctors, lawyers, bankers, businessmen, and corporate types from Brooklyn and New York City—were sociable and fun-loving. They loved their beach, took up sailing, played tennis, and established a country club in 1916 to encourage sociability, song, and dance. The Shoreham Country Club was first housed in a seaside log cabin. In 1916, a clubhouse was built, and in 1935, it was remodeled and expanded in grand style. It was used until a fire destroyed it in 1987. Most of the postcards in this book are from Shoreham's heyday as a summer community.

After the stock market crash of 1929 and the discontinuance of rail service in 1938, Shoreham entered a period of decline. After World War II, the establishment of large local employers, including Brookhaven National Laboratory and Grumman Aerospace, spurred the development of Shoreham beyond the village limits. Gradually, Shoreham Village transitioned into a year-round community. Through it all, the traditions and institutions continued such as summer fun on the beach, social activities centered around the country club, the parade and festivities on the Fourth of July, and of course, the tennis, including the uninterrupted nearly 90-year annual tournament with Wading River.

The two good neighbors, Shoreham and Wading River, share a school district, a longtime tennis rivalry, and a future. Challenges await, but the communities continue to grow, their determined people working together to make decisions that will improve the quality of life for their residents and all those who visit.

One

HISTORIC WADING RIVER
THE SANDS OF TIME

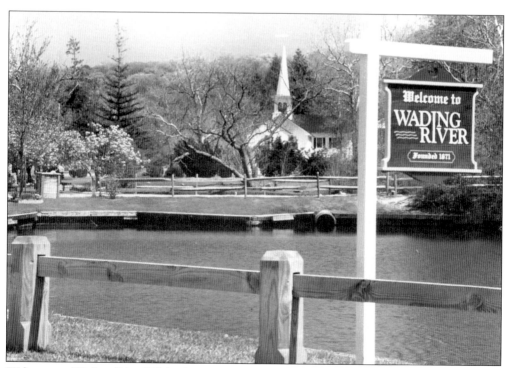

Welcome to Wading River! This picturesque village, established over 300 years ago, is nestled on the north shore of Long Island. In the spring, cherry tree blossoms are reflected in the twin ponds of the old downtown, where people come to feed the waterfowl, get an ice cream cone, or have a pizza. The historical society and the church are at opposite ends of the ponds. (JA.)

High above the Long Island Sound sit many large glacial erratics, boulders carried down by glaciers during the last ice age. The bluffs were formed by the final approach and retreat of the last glacier. These boulders are part of what is known locally as Split Rock, so named because the stone appears to have split into several large sections creating a space like an inverted pyramid between them. Split Rock has always held an attraction and may have been a gathering place for the indigenous people of the area. Its location high on a hill offered expansive views. This region was home to the Corchaug and Setalcott people (Algonquian) over 5,000 years ago. The remnants of their occupation in the area have been found in shell middens and in arrowheads of the "Wading River" style. (JA.)

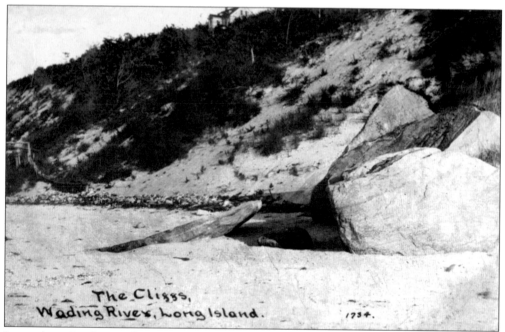

The Cliffs,
Wading River, Long Island. 1734.

Located on the shores of Long Island Sound, the community has a strong association with the offerings of the marine environment. This 1905 view shows the cliffs and some erratics strewn along the beach. It also shows stairs (on the left) up the bluffs to a house perched overlooking the Sound. (JA.)

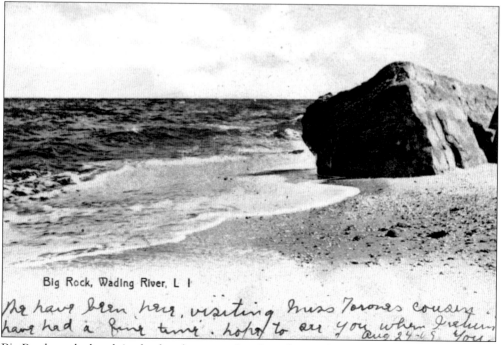

Big Rock, Wading River, L I

We have been here visiting Miss Torones cousins. have had a fine time. hope to see you when I return. Aug 24 05 You

Big Rock on the beach is a landmark to many beachcombers and swimmers in the area. Deposited by glaciers, it found its most recent home east of the public Wading River Beach and west of Wildwood State Park Beach. This card was postmarked in 1909. (JA.)

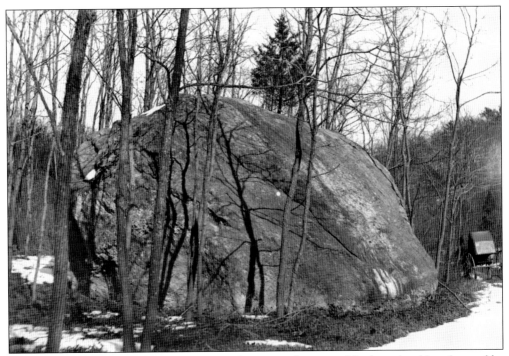

This large boulder is known as Billboard Rock. It is another one of the huge boulders dropped by glaciers during the last ice age. Found at a turn on North Country Road, it may have received its name as a place where signs were posted. It was also known as Tuthill's Rock, due to its location on land near one of the old Tuthill family homes. Note the horse-drawn buggy to the right in the top photograph, which was taken on February 27, 1901. The bottom photograph could have been taken at the same time, with the tree growing from the top. It looks much the same today. (WRHS and SUFFOLKCOHISSOC.)

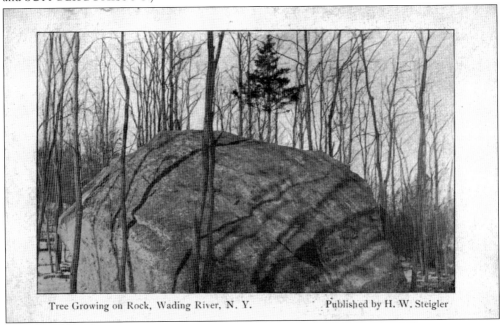

Tree Growing on Rock, Wading River, N. Y. Published by H. W. Steigler

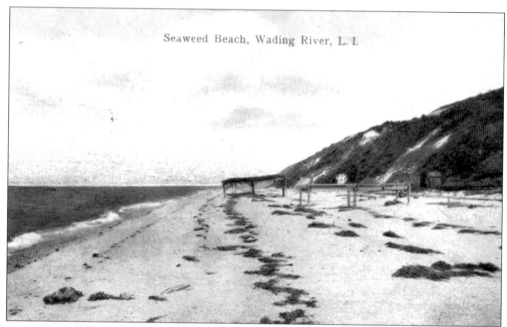

Seaweed Beach is an accurate title for this view, with lines of seaweed showing the height of the tide over time. Grass-roofed shelters were helpful protection against the strong sun, and small shacks can be seen at the foot of the cliffs. (JA.)

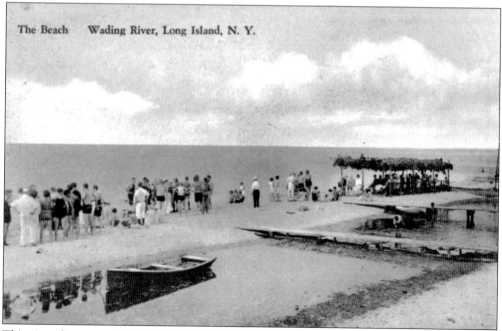

This view shows a sandbar that had been created by the tides. The local people have built a shack for shade at the beach, and some plank bridges were constructed across to the sandbar. This one has had several bridges built to provide a means over the water. (JA.)

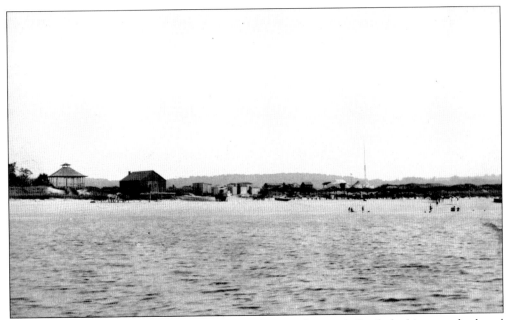

Seen from the water, this shows the beach around 1905 when each family had its own shack and bathhouse. Bathers can be seen on the right, and some of the horse-and-buggy conveyances are also visible. This view shows what is now the public beach. (CE.)

Boulders emerging from the water were useful for judging tides but were hazardous as well. The rock at far left was known as the Lay Ashore rock and was used by ship captains to know when the tides were too low to come safely to shore. (CE.)

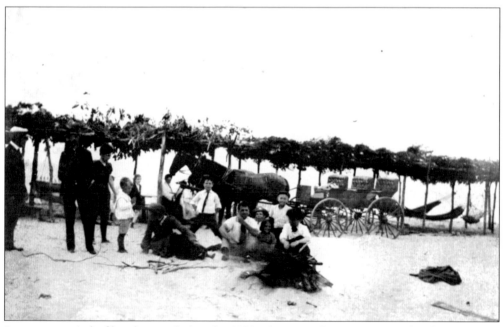

In a scene typical of beachgoers during the 1890s, these people are enjoying a bonfire near their shacks. The horses and buggies brought revelers right to the beach and waited until the return trip. Note the hammocks slung from the poles to the right of the photograph. (WRHS.)

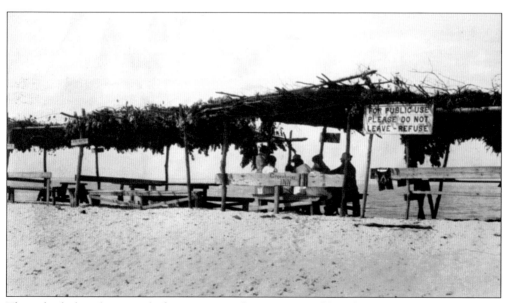

These shacks lasted a season before autumn and winter storms blew them away. The shack reserved for patrons of the Greenbrier Inn is at center, and one built for public use is to the right. The others on the left are labeled with the names of those who claimed them. (CE.)

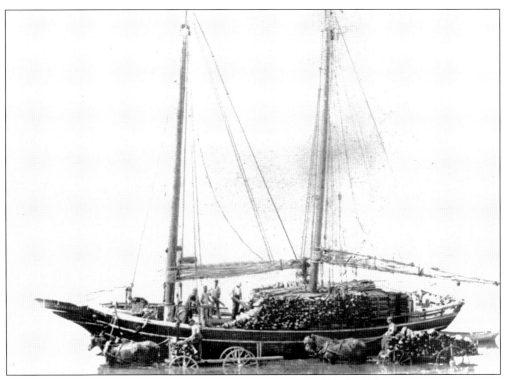

Wading River was once a center for shipbuilding. There were two shipyards along the beach in the early years—one at the end of Sound Road and the other at the mouth of the creek. The ships were loaded with cordwood to be sailed to New York City and up the Hudson River to the brick-firing kilns. Logs were stacked along the roads leading to the beach to await the sloops. The *Olive Leaf* is shown above around 1898 as it is being loaded at the end of Sound Road with logs cut from local woodlands. On the left is the *Alert*, loaded and ready to go with the tide. (CE and WRHS.)

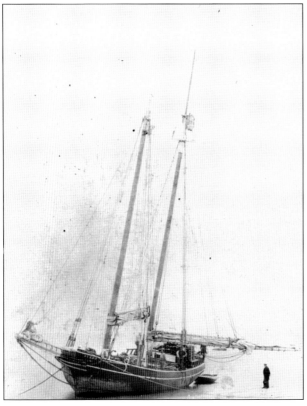

18

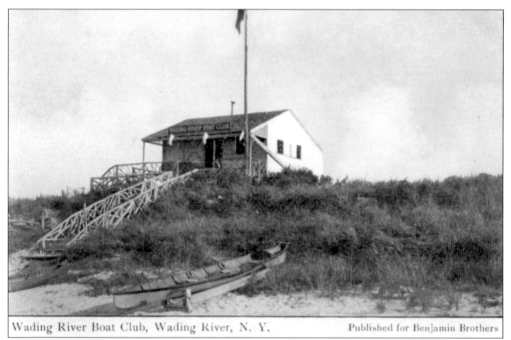

Wading River Boat Club, Wading River, N. Y. Published for Benjamin Brothers

The Wading River Boat Club was organized to have a place to store watercraft on the beach. Active at the beginning of the 20th century, the Wading River Yacht Club made Pres. Theodore Roosevelt an honorary member, as reported in the *Sag Harbor Corrector* on November 18, 1905. (LJ.)

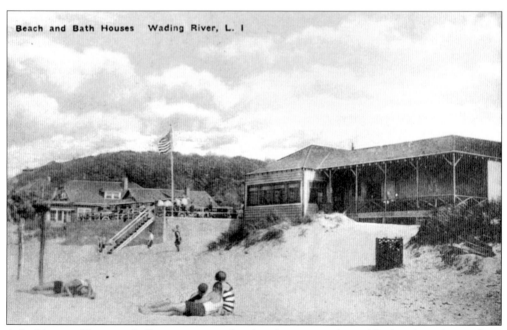

Beach and Bath Houses Wading River, L. I

A bathing pavilion was built to accommodate beachgoers on the public beach with a parking area on the east side. Changing rooms and a restroom were available to make beach visits more comfortable. (LJ.)

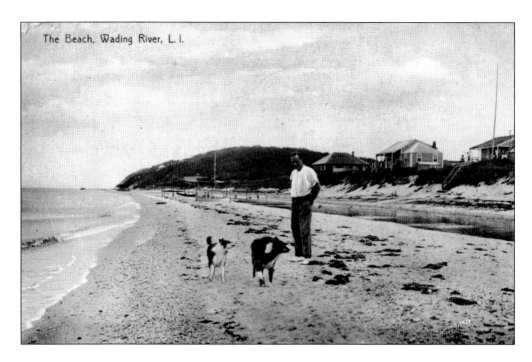

The Beach, Wading River, L. I.

Postmarked 1919, the top scene could have been photographed recently. People and their dogs walking along the beach are still a common sight. There are many postcards of the Wading River beach, proving the strong attraction the water and sand had for the population. In the bottom image, permanent summer cottages along the beach had not eliminated the need for shacks being used for shade nor the umbrellas that had started to become more popular. Regardless of the era, the beach beckons. (JA.)

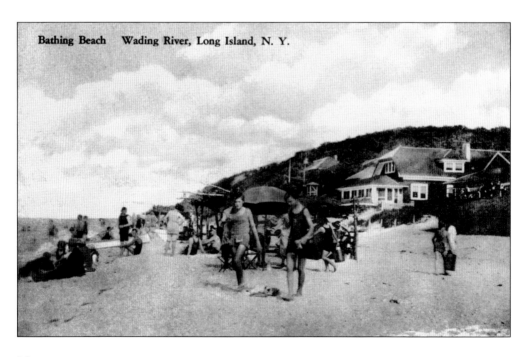

Bathing Beach Wading River, Long Island, N. Y.

Two

Building the Community
It Makes a Village

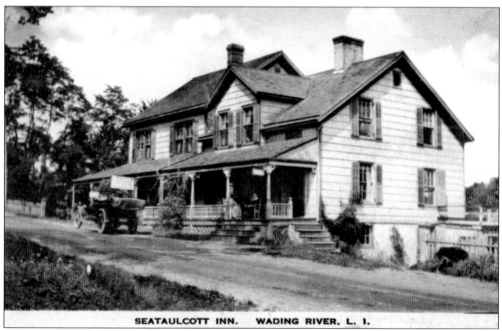

SEATAULCOTT INN. WADING RIVER, L. I.

Seataulcott Inn was once the home of Jonathan Worth, owner and operator of the gristmill during the Revolutionary War. It later became a boardinghouse and then a private home, which it remains today. The house sits on North Country Road near Randall Road and overlooks the Mill Pond at the rear. (LJ.)

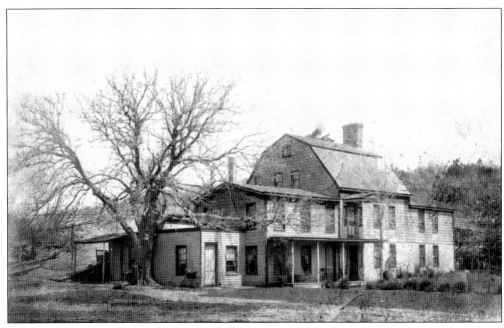

Owned by the Tuthill family at the time of this photograph, the home was part of a working farm. Its original section had additions built to form the house seen here. Hired help lived in the upstairs rooms. (CE.)

The Tuthill barns were across the road from the farmhouse. The hills and salt marsh, or "meadows" as they were known, can be seen behind them. Cordwood was stacked along the road near these buildings to await transport on the sloops. (CE.)

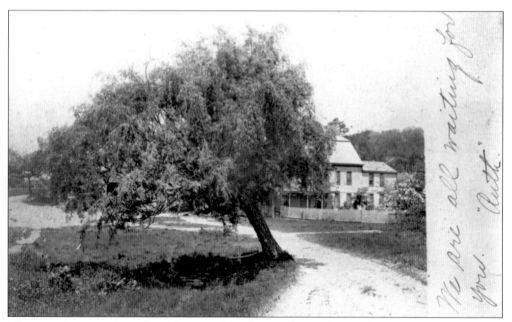

The same house and road can be seen here before the road was changed. A fence is visible around part of the yard. The original part of the house was built by Bartley Fanning Tuthill in 1820. (CE.)

The barns sit on the west side of Sound Road, a few hundred yards south of the beach. They have been remodeled into a private home. Note the automobile coming over the rise from the beach. (CE.)

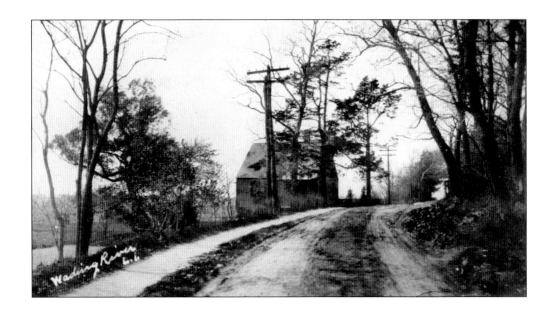

Sunset Cottage sits alongside Sound Road, with the salt hay meadows and Mill Pond on the left and a sidewalk along the road. Several older houses that line Sound Road date to around the Revolutionary War. Most are on the hill on the east side of the road and face Mill Pond and glorious sunsets over the Sound. Closer to the village, the sidewalk continues along Sound Road and passes by another old house on the left. (JA.)

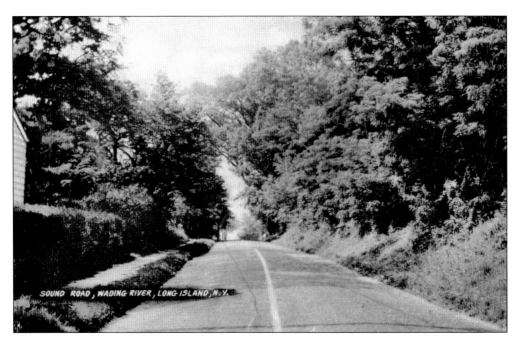

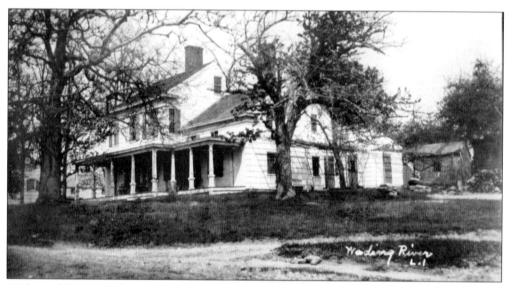

With an addition built by Benjamin King Woodhull around 1845, this house has an original kitchen and dining room section believed to be from around the time of the American Revolution. A very old barn on the property burned down following a lightning strike but was rebuilt using timbers from the same era. (JA.)

This house is believed to have been built by Benjamin Glover and by 1832 was owned by Ellsworth Tuthill. Its Dutch gambrel roof makes its style very distinct for early Wading River. In the late 1920s, Henry Reppa removed additions and changes that had been made in 1858 and the early 1900s. Reppa was the first superintendent of Wildwood State Park. (JA.)

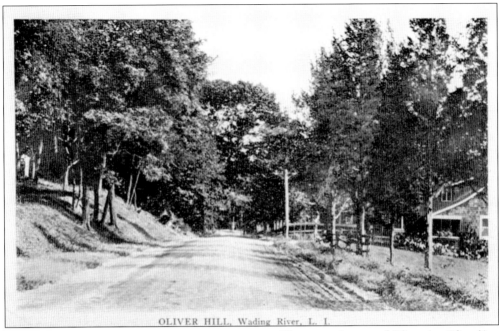

OLIVER HILL, Wading River, L. I.

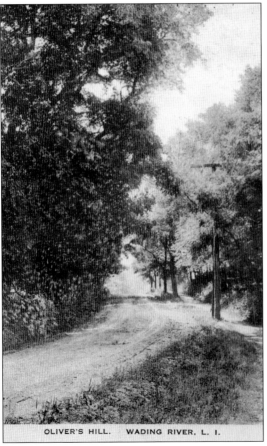

OLIVER'S HILL. WADING RIVER, L. I.

These two images of Oliver (or Oliver's) Hill face south toward Wading River village. On the left in the top photograph is a rise upon which the Oliver Hill Cemetery exists. Many of the original burials were for the Hudson family. Revolutionary War patriot Henry Hudson is buried there as is Maj. Frederick Hudson, a British sympathizer. Frederick's son Oliver is also buried there and gives his name to the cemetery as well as to Oliver Street across Sound Road. The cemetery was part of land sold to George Hudson by Gabriel Mills in 1811, with the notation in the deed that there was a "one acre burying ground" for the church. (CE and LJ.)

In the c. 1850 photograph above, the dirt roads that became North Country Road and Zophar Mills Road intersect. Today, the Wading River Historical Society building, the Pizza Pie and General Store, and the public parking lot face each other at the intersection. When work was done a few years ago to repair underground utilities, a corduroy road made of logs placed side-by-side was discovered under this spot. The cows in the bottom photograph are enjoying the cool Mill Pond waters. (WRHS and SUFFOLKCOHISSOC.)

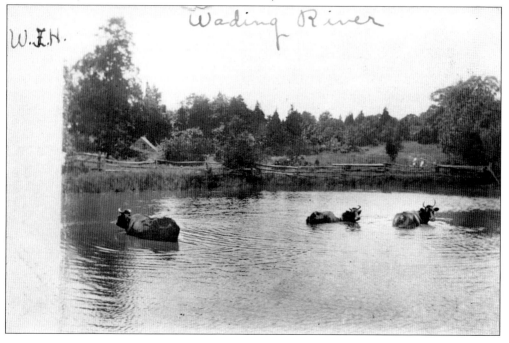

The sender of the card above described Mill Pond from one end to the other as "A pretty spot, where the lilies bloom, beside the store overlooking the Mill Pond." From the point where it meets Long Island Sound, the Wading River flows with spring-fed fresh water in a meandering path with several branches through the marshlands, or meadows, until it meets up with the salt water. The bottom photograph, taken on October 1, 1914, shows a spot near where the river meets the Sound and where the shellfish were once abundant. On the rise in the distance is where the defunct Shoreham Nuclear Power Station was built. (CE and WRHS.)

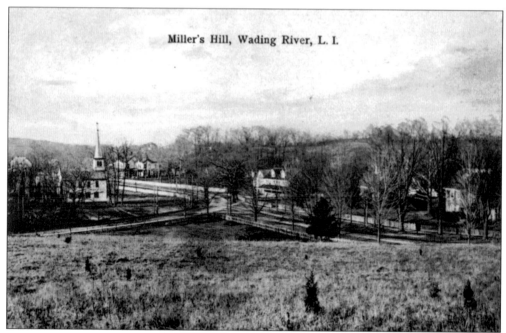

Miller's Hill, Wading River, L. I.

Seen from the top of Miller's Hill, the village of Wading River looks serene. At left is the Congregational church, with the ponds hidden from view behind it. In the distance at the far left, the general store can be seen. Moving towards the right, the Greenbrier Inn is visible in the distance, and in the center, Homan's Tavern is located at the intersection. Farther to the right is the Miller homestead. The intersection is at North Country Road and North Wading River Road, looking northwest. Below is a closer view of the Greenbrier Inn. The Greenbrier Inn was a private home occupied by the Corbett family when it was not an inn. It is now gone, replaced by other buildings. (JA and LJ.)

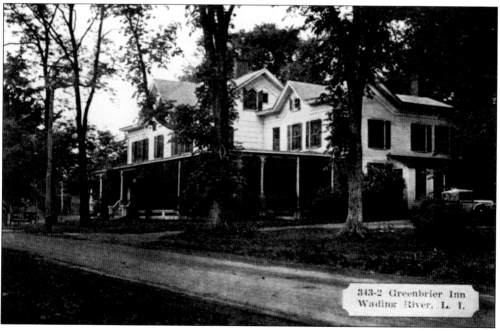

343-2 Greenbrier Inn
Wading River, L. I.

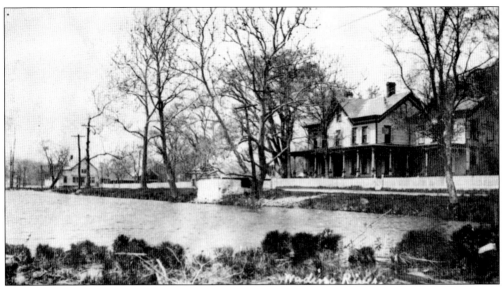

Viewed from across the pond, the Greenbrier Inn and the general store are visible, as is the springhouse in the pond. The inn used the springhouse to store dairy and other items that needed to be kept cool. In the photograph below, it sits beside an old sycamore tree, which may be the one that still stands today. The photograph of the springhouse was taken in August 1905. Note that the pond is one long pond before Zophar Mills Road was built through it, dividing it in two. Today, it is often called the Twin Ponds or the Duck Ponds and is celebrated each spring with a community fair along the street. (JA and WRHS.)

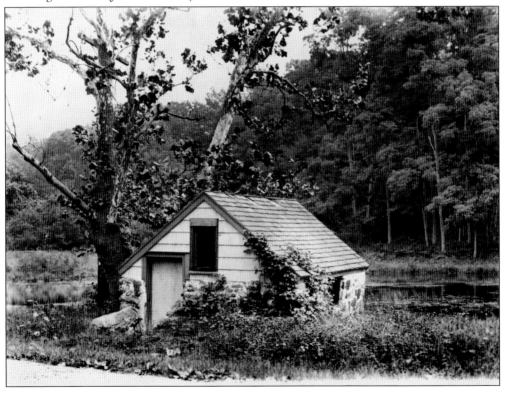

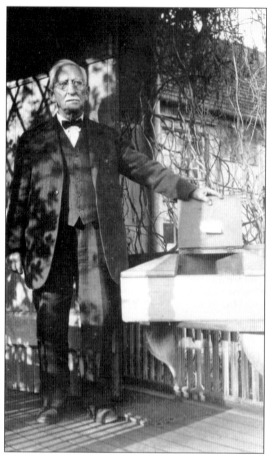

Elihu S. Miller stands alongside the original Wading River "post office" used by his ancestors—a triangular gray-blue box that stood in the front room of his family's homestead where residents would pick up or drop off mail. Later, a larger desk with cubbyholes for the mail replaced this box. He was the postmaster from 1869 to 1885. Zophar Miller was the postmaster from 1825 until Sylvester Miller took over in 1844. Elihu followed in 1869. In 1922, the post office was located across the street from the Miller homestead at the corner of North Country Road and North Wading River Road. The road going up the hill led to what is now Route 25A. William L. Miller, postmaster from 1916, owned the building. (WRHS and JA.)

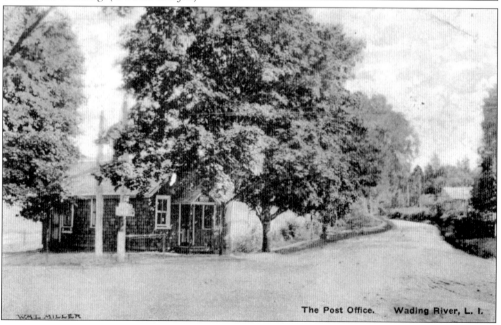

The Post Office. Wading River, L. I.

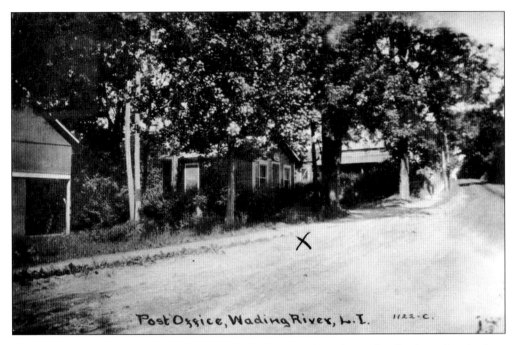

Post Office, Wading River, L.I. 1122-C.

Between the years 1888 and 1916, the postmaster was not from the Miller family, and again from the 1920s on, others held that position. In March 1935, while Elmer Bishop was postmaster, he moved it to a store at the entrance to Wildwood State Park. The ensuing uproar ensured that it was returned to the village, where it had been for most of its existence, though not always in the same building. It was in the village general store and other buildings nearby when it was not in one of the Miller buildings. In 1959, it was moved to the brick building that stood on the site of the former Greenbrier Inn, until it moved in 1990 to Wading River Manor Road near Route 25A. (JA.)

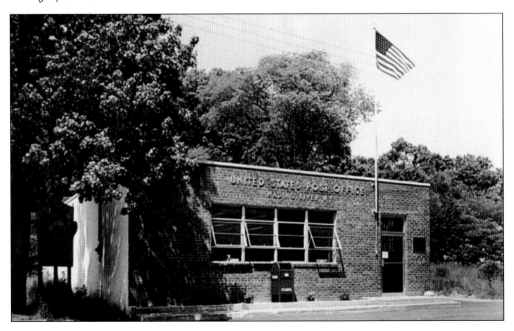

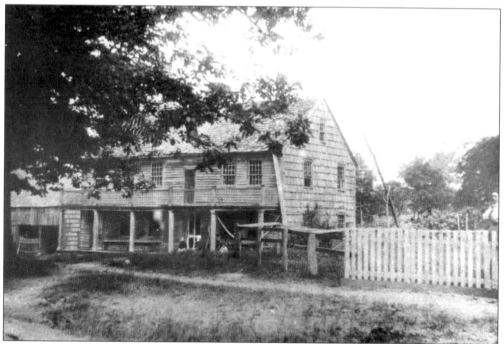

Homan's Tavern was located at the intersection of North Wading River Road and North Country Road. Built before 1750, it was reputed to be a well-run enterprise, known for its "mulled cider and flips." According to some records, there were "balls" and "wedding suppers at the Homans." Benjamin Homan owned and ran the inn until his death and was followed by his son Stephan. When Stephan died, his wife carried on until her son Benjamin was old enough to run it. In the top photograph, several people are sitting on the front porch, and a woman, perhaps Fannie Mills Homan, stands to the far right. The bottom c. 1900 photograph shows some remodeling to the front of the building and a new fence. The building was in existence in the 1930s. (WRHS and CE.)

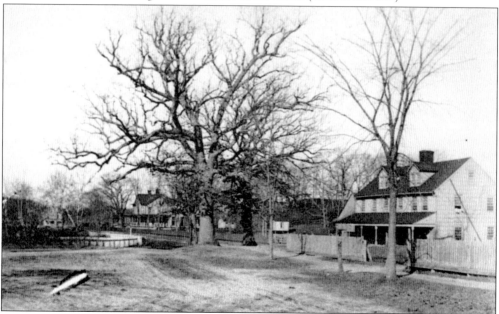

W. Donie, usually known as "Uncle" Donie, and his wife, "Aunt" Donie, lived in this house on the western edge of Mill Pond above the Roe mill. He was known as an expert in steel work, manufacturing knives and other household tools. The house, built around 1740, burned down in 1910. This photograph was taken on May 16, 1901. (CE.)

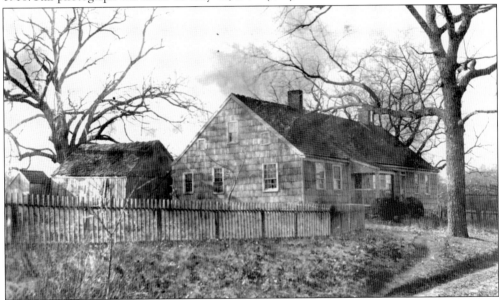

This house was built by Zebulon Woodhull, son of Josiah Woodhull and grandfather to blacksmith Alonzo Woodhull. Note the two gun windows on either side of the attic window. The house was purchased by Robert Gosman in 1865. It was situated on North Country Road and was the Wading River Rod and Gun Club for a time until it burned down. (CE.)

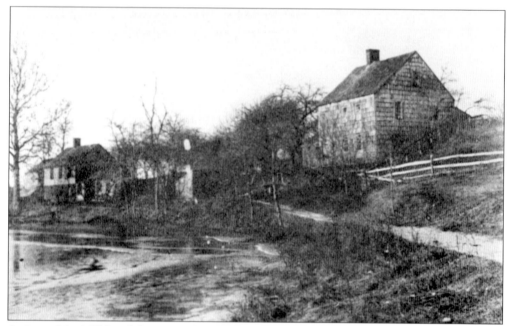

A view of the Mill Pond shows North Country Road and the home of "Auntie Brown." She may have been Clarissa Woodhull Brown, widow of church deacon Luther Brown. On the left is Two Wells, which was built by Jonathan Worth in 1790 and later run as the Seataulcott Inn. (CE.)

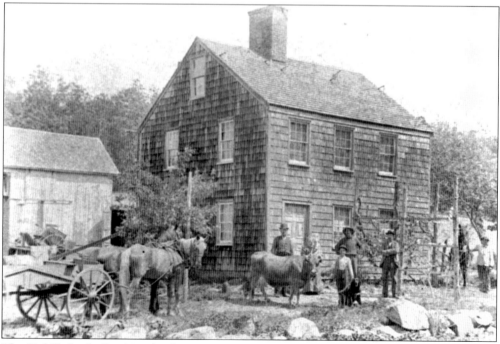

The Tuthill family lived in this house and called it Happy Hollow. The men and a boy who gathered outside for this photograph brought out the horses, buggy, cow, and even the dog. Built before 1837 by J. Tuthill on the old Tuthill property, it was remodeled in 1921. (WRHS.)

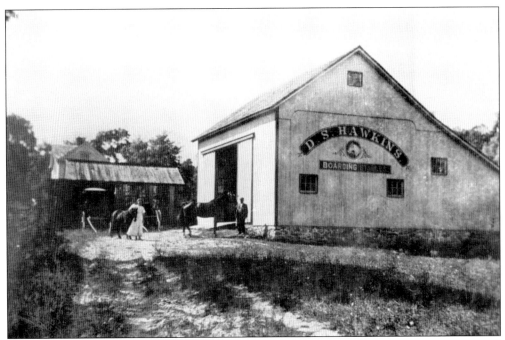

The stables shown here were owned by the Hawkins family and located at the corner of North Country Road and Gabriel Mills Road. During Prohibition, cars that distributed alcohol throughout the region were sometimes kept here. Illegal alcohol was shipped in to the quiet beach landings, which had been used in earlier times for log-carrying sloops. (WRHS.)

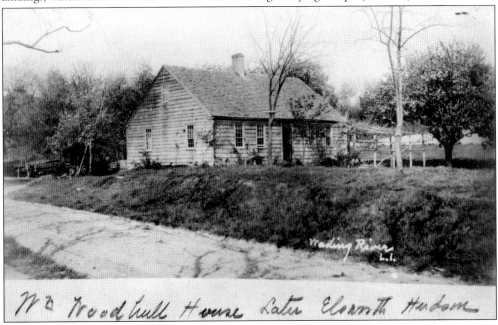

Built in 1840 by William Woodhull, this house became the home of Ellsworth Hudson. His daughter Hannah grew up in this house and eventually married William L. Miller. This photograph is from 1890. The house was along Sound Road but did not face the road; rather, the front of the house faced south. It burned down in 1930. (CE.)

The mill (above) was one of three in the village. Probably the gristmill built in 1708 by John Roe Jr., on the Mill Pond, it was in operation for about 200 years. After a succession of owners, it came to Capt. George Hawkins. He was the last of the gristmill operators in the community. Along with the gristmill, there was a log mill, and another, the type of which is not recorded. None remain. One of the mills, located near the Josiah Woodhull house across the drive, is believed to be the sawmill built by Henry Perring and later operated by Mr. Woolley. It was known as Woolley's Mill. The mill pictured below, in a state of great disrepair, is either Woolley's Mill or the gristmill. The location of the first mill, owned by Daniel Lane, Jr., is unknown. (CE and JA.)

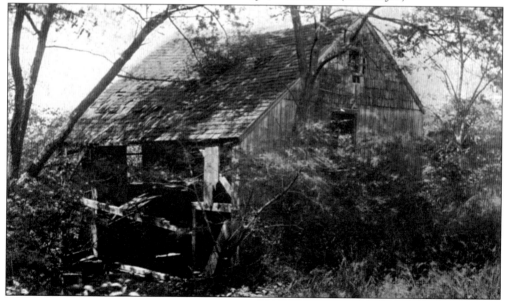

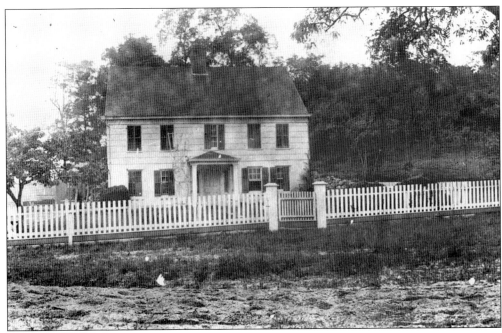

The Josiah Woodhull house, built before 1720, was constructed on land granted to his grandfather Richard Woodhull in one of the first land grants in Wading River on November 23, 1675. The original house was lifted to build a new first floor under it. On the left of this photograph, just out of range, is the barn and Woolley's Mill. The sawmill was built in 1710 on the stream at the side of the house. Note the dirt road in front, which is North Country Road. Francis Woodhull, pictured below, was the last of his family to live in the house. It now belongs to the Town of Brookhaven, which is restoring it. (WRHS.)

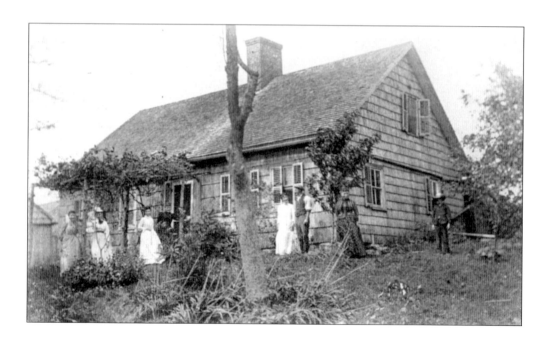

Built around 1789, C.J. Payne lived in this house (above) in 1873. It was better known as the Ernest Payne house. Payne was the grandson of C.J. It was eventually owned by Oliver Paine. On March 12, 1927, the house and 122 acres were sold to Fr. Bernard J. Quinn. It stood on North Wading River Road at the entrance to what is now Little Flower Children's Services. It was destroyed by fire on August 7, 1928, possibly by the Ku Klux Klan. Below is the Congregational church parsonage as it appeared between 1910 and 1912. This building is now a residence and located just south of Remsen Road on North Country Road. (CE and LJ.)

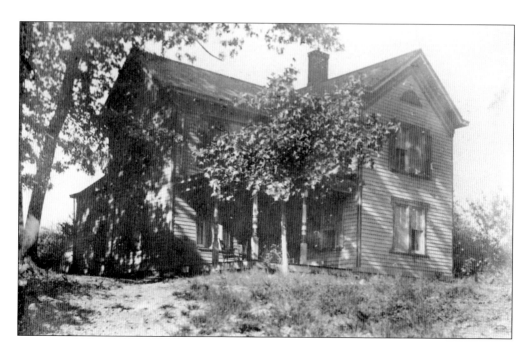

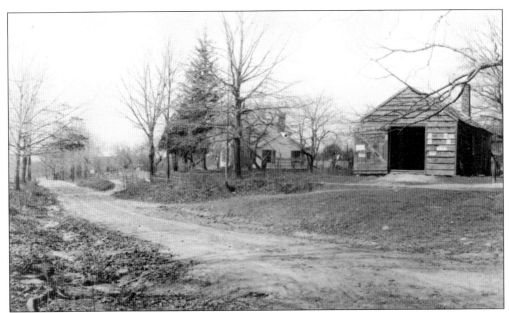

Alonzo Woodhull was a blacksmith who worked from this barn on Wading River Manor Road. He was trained by Hiram Noyes, who kept a blacksmith shop and forge on the south shore of Mill Pond. By 1840, Alonzo had this shop, located north of his father's house and store and across the road from the wheelwright's building. Below is his father's house, built by Josiah Lupton c. 1760, with a large white oak in front. At the base of the oak was a mile marker, which told the distance to Riverhead and Port Jefferson and was part of the system set up by postmaster Benjamin Franklin. The tree grew around the marker, and a second one was placed there. The tree was partially cut down in 2012, although the mile markers remain inside. It was once one of the largest on Long Island of its type. (CE.)

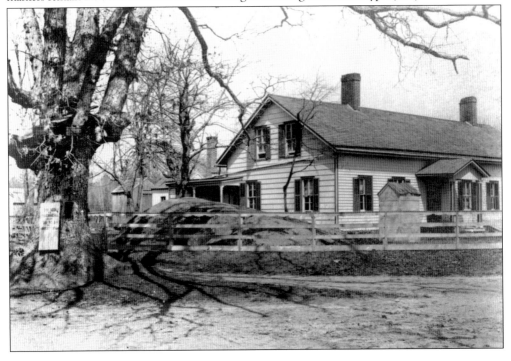

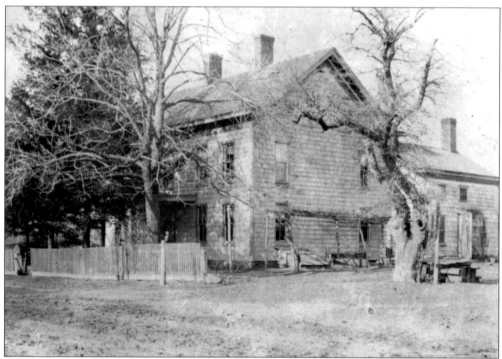

Hillcrest Farm was owned by Josiah Lupton, who built several homes in Wading River. Nathanial Woodhull purchased this house on January 30, 1812, from Phoebe Lupton, Josiah's widow. In 1877, when these photographs were taken, Egbert Woodhull lived there and is seen standing outside in the bottom photograph. The horse block, which was used for assistance in climbing into carriages, still rests in front of the house on North Country Road, formerly Parker Road. On part of the property owned by Lupton is another house called the Little House. This family farm remained in operation by the Woodhull family and descendants for over 100 years, placing it on New York's list of Century Farms. (WRHS.)

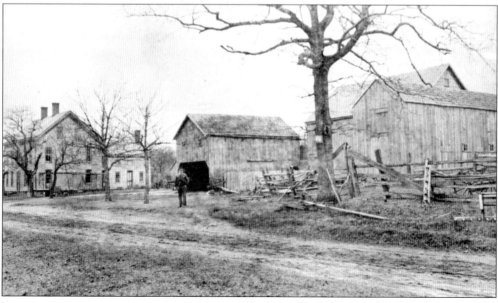

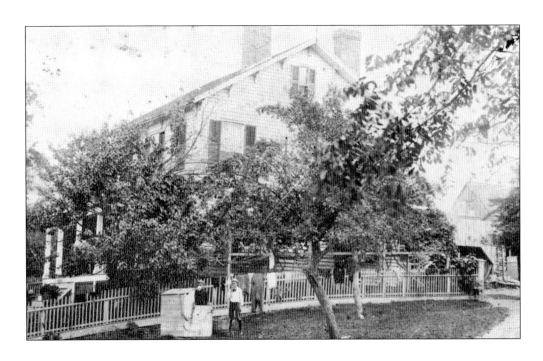

Visible above is the south side of this Sound Road house belonging to Samuel H. Rowley, who went to sea as a cabin boy at the age of 13 around 1836. He became a captain and sailed for over 45 years, for a time aboard the *Helen M. Rowley*, a brig named for his wife. His sailing ships often left from Sag Harbor. His son Cliff Rowley is seen standing alongside the fence with another person in the photograph. Note the clothing hanging on the fence. In the image below, Cliff Rowley stands along the front fence, and a view of the Sound can be seen in the distance. These photographs were taken in 1894. (CE.)

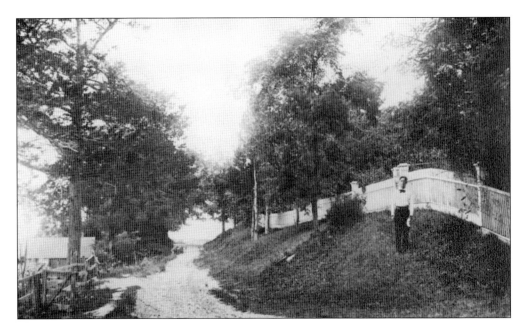

There have been several schools in Wading River. At first, parents taught their children. Eventually, a school was built around 1813 on North Country Road, called the "downstreet" or "mainstreet" school. There were two districts: District 1 in the Brookhaven portion of the town, and District 13 centered on North Wading River Road near Wildwood, called the "upstreet school." The next downstreet school, built around 1870, was updated in 1895 and replaced in the 1920s. The photograph at right is from 1894, and the bottom photograph with students and a teacher is from the early part of the 1900s. (CE and WRHS.)

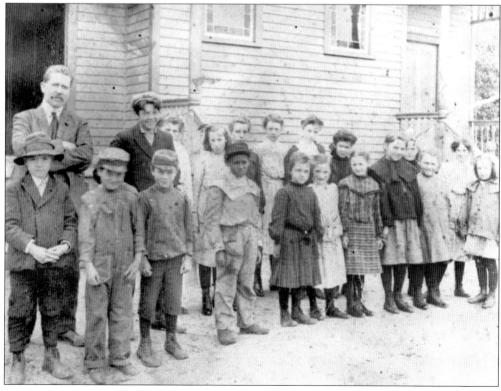

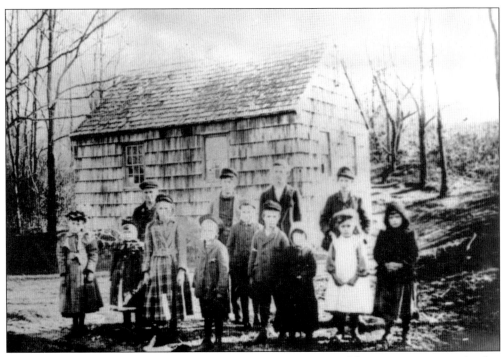

The eastern upstreet school was built in 1827, replaced in 1870, and replaced again in 1900. The school shown here is from around 1890 and is the second upstreet school. When it was eventually closed, it became a Wildwood community center. This part of Wading River sent students to Riverhead. (WRHS.)

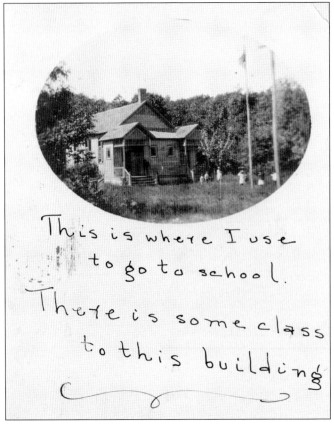

This is where I use to go to school. There is some class to this building

The downstreet school as it appeared in the 1920s had two entrances, one for the boys and one for the girls. The building still stands on Wading River Manor Road, to the south of the Wading River Fire Department. It is now a private home. (LJ.)

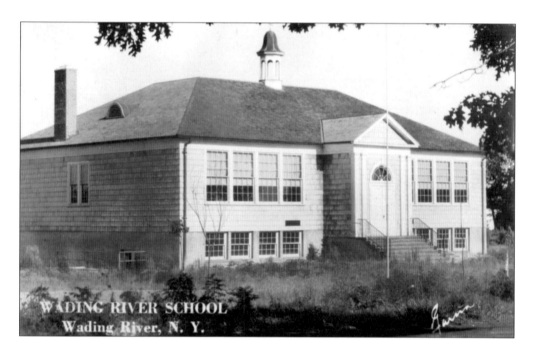

WADING RIVER SCHOOL
Wading River, N. Y.

Wading River School District and Shoreham merged in 1973 to form the Shoreham–Wading River School District. The current Wading River Elementary School is built where there was once a three-room schoolhouse. Constructed in the late 1920s or early 1930s, it housed several grades in each of two classrooms with a space for offices and storage. Students up to eighth grade attended there before going off to high school in Port Jefferson. The top photograph shows when it was first completed, and the bottom photograph shows it a few years later. In 1963, this building was replaced with the current Wading River School. (LJ.)

PUBLIC SCHOOL, WADING RIVER,
LONG ISLAND, N.Y.

45

This is an unidentified road, but a highway planned in 1702 from Southold through Baiting Hollow ended in Wading River. "The high way from ye towne of Southold to ye westward farms on ye northside to be ye usuall road to Mattatucke and see on ye northside of ye pond in ye way lately marked out to ye usuall road leading to Richard Howells and from thence in ye usual road to ye beach and so on ye beach to ye fresh pond and to ye place called ye wading river" (*History of Mattatucke* by Rev. Charles E. Craven). Following the North Shore, it traversed the beach part of the way. One part of the road still exists, which is Creek Road. By July 25, 1710, the road was complete. The horse and buggy seen on the beach are on what may have been part of this highway. (JA and CE.)

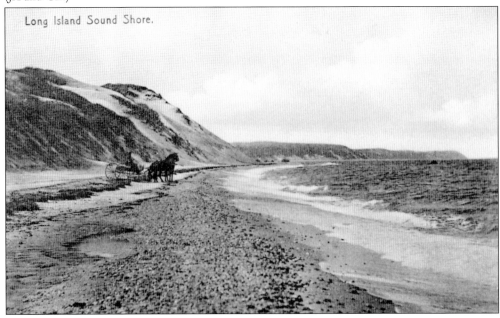

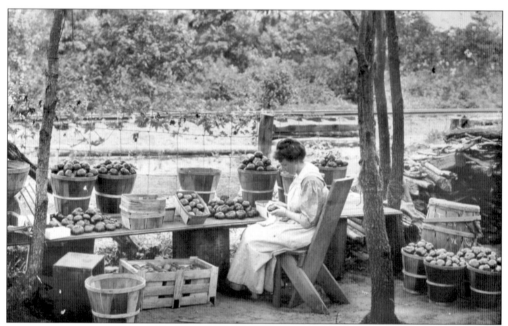

In 1905, the Long Island Railroad president challenged photographer and author Hal B. Fullerton and his wife, Edith, to establish a farm near the Wading River railroad line. Within a year, the Fullertons had planted a wide variety of vegetables on 18 acres in Wading River at the farm called Peace and Plenty, LIRR Experimental Station No. 1. Their success led them to write about and photograph the farm and its development, to establish innovations in farming, and to create another experimental farm in Medford. These were intended to encourage people to move east, purchase land for farms, and use the railroad for travel and shipping goods. Edith Loring Fullerton can be seen packing tomatoes in the top photograph, and Italian farm workers are collecting sweet potatoes in the bottom photograph. (SUFFOLKCOHISSOC.)

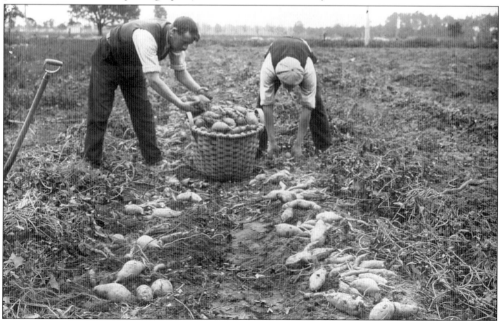

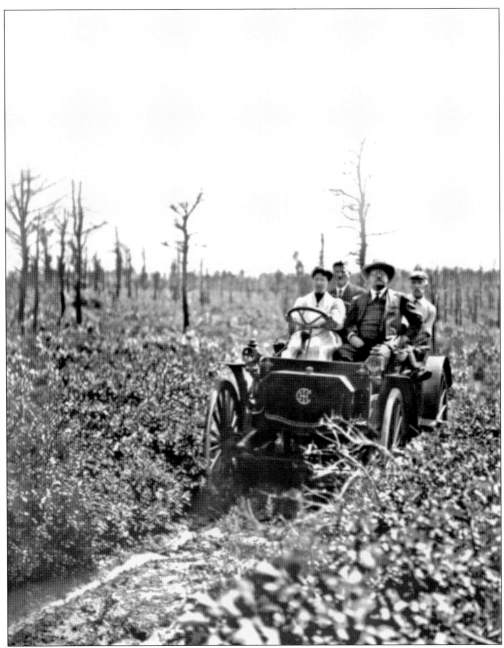

Former president Theodore Roosevelt visited Peace and Plenty on August 10, 1910, with LIRR president Ralph Peters. Edith and Hal Fullerton hosted them. The Medford Farm had just been completed. Roosevelt's presence was intended to bring publicity to the farming initiatives of the Fullertons and the railroad, and the day included a meal prepared from food grown on the farm. The railroad provided a special train car to bring the New York press to report on the event. According to the *New York Times* report, on the way to Wading River from Medford, they got stuck in the mud near Artist Lake where the road was washed out. Roosevelt assisted the others in dragging the car out, and they continued to Wading River. This photograph by an unknown photographer was taken near today's Route 25A and Randall Road. (SUFFOLKCOHISSOC.)

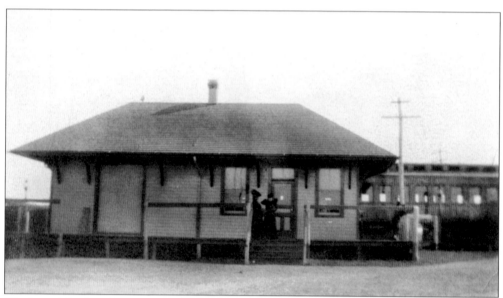

The Long Island Railroad built its line out to Wading River in 1895. The first railroad station was one story. There was a morning and an afternoon train on the line, which took Wading River students to high school in Port Jefferson and other passengers as far as New York City. (WRHS.)

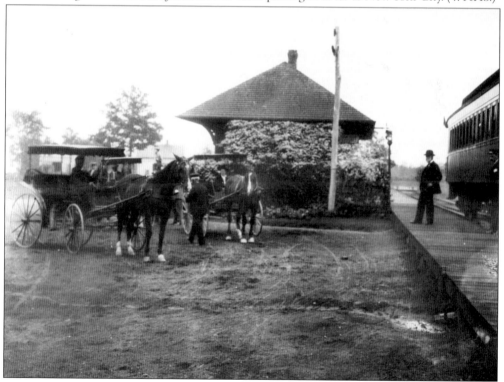

Once located where there is now a shopping center on the north side of Route 25A, the station helped the community grow. Judge's Hotel, seen in the rear at left, and other businesses came to the town. A second story was later added to the station for the stationmaster's living quarters. The railroad closed down the line to Wading River in 1938. (JA.)

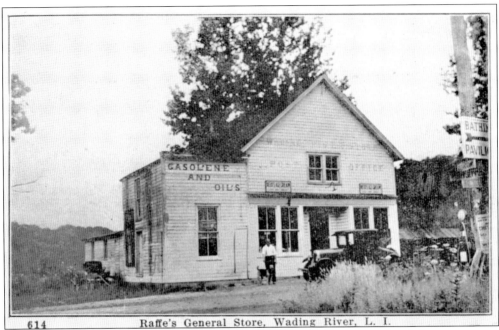

614 Raffe's General Store, Wading River, L. I.

Raffe's General Store is pictured in the early part of the 20th century, and at left one can see a wagon without its horse while a "horseless" carriage sits in front. At right on the tree is a sign directing people to the bathing pavilion at the public beach at the end of Sound Road. (JA.)

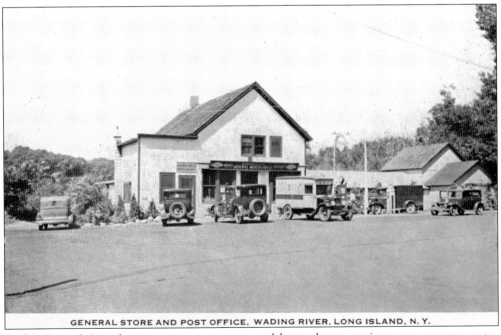

GENERAL STORE AND POST OFFICE, WADING RIVER, LONG ISLAND, N. Y.

Raffe's General Store became more prosperous, and horse-drawn carriages gave way to motor vehicles. The Wading River post office moved to the store for a while around 1888. Charles E. Wells was the postmaster then, followed by John N. Gosman in 1895, Daniel W. Arnold in 1900, and William L. Miller in 1916. (JA.)

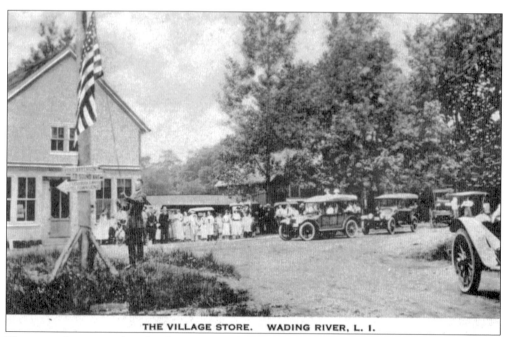

THE VILLAGE STORE. WADING RIVER, L. I.

The general store continued to be a center of activity in Wading River, and at the time of this photograph, a crossroads sign indicated the direction to the beach and to other nearby locations. There is a flagpole in the center of the crossroads and a parade of cars and people, probably gathered to celebrate a special event or date. (JA.)

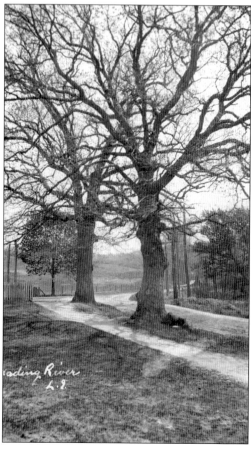

This cluster of trees, with the well-sweep in the left rear, stood at what is now the intersection of North Country Road and North Wading River Road. It is in front of the Miller Homestead. The road goes up the hill toward Wildwood State Park. The portion of the road was near the Miller homestead. The road layout was changed some time after this photograph was taken, and the road no longer curves this sharply. (JA.)

51

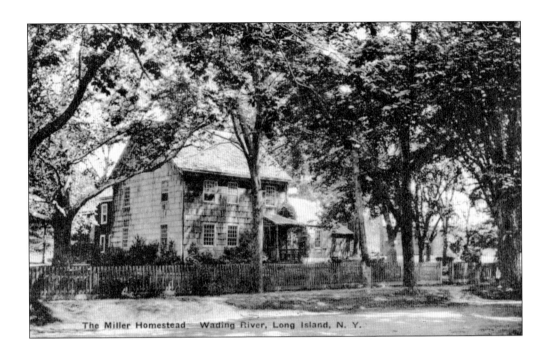

The Miller Homestead – Wading River, Long Island, N. Y.

One of the oldest homes in Wading River is the homestead belonging to the Miller family, where generations of Millers lived. The house was built in 1799 by Zophar Miller. The Miller family was active in community affairs with its members serving as postmasters and even as Riverhead town supervisor. Sylvester Miller was elected to that post in 1841 and reelected to serve a total of 19 years. He also served as town justice of the peace for 28 years and as postmaster for 25 years. Elihu S. Miller was a noted botanist and ran a seed business from Wading River. His son William L. Miller had a real estate office in Wading River. (JA and CE.)

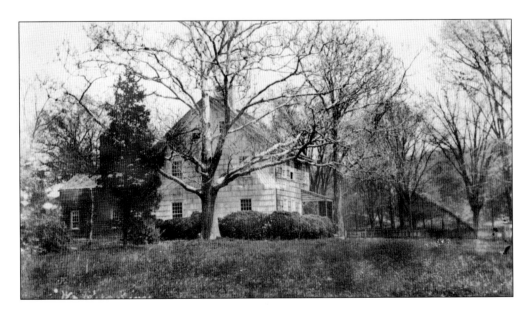

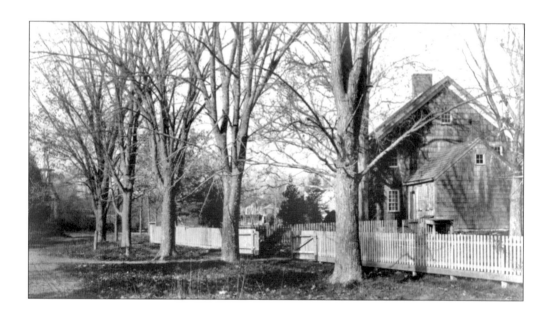

In the early part of the 20th century, the Miller homestead appeared as seen here, looking west. In 1832, when his son Sylvester married, Zophar Miller had the cottage (below) built for himself and his wife while Sylvester and his wife were given the homestead to live in. The photograph is from prior to 1910. After that time, William L. Miller and his wife, Hannah Hudson Miller, added a dormer window. William was the great-grandson of Zophar Miller and son of Elihu S. Miller. At the left, a well-sweep can be seen, which helped raise a heavy bucket of water from a well. (CE.)

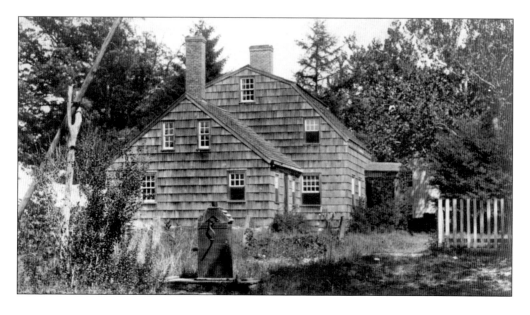

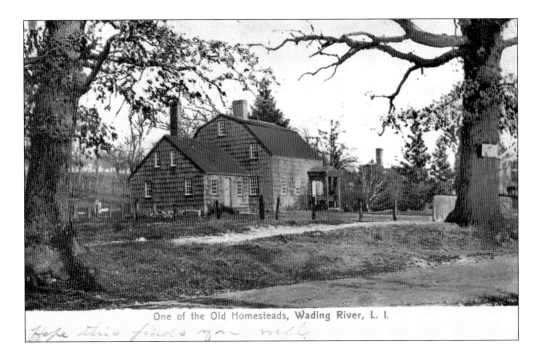

One of the Old Homesteads, Wading River, L. I.

The Miller cottage sits east of the intersection of North Country Road and North Wading River Road where Homan's Tavern once stood. The top photograph, taken prior to 1910, shows a sidewalk in front of the house and the chimney of the old homestead behind it. The bottom image, taken after 1910, has the dormer added, and of course, the small evergreens in the earlier photograph have grown quite large. (JA and LJ.)

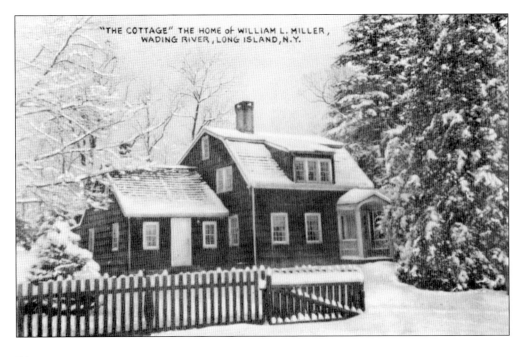

"THE COTTAGE" THE HOME of WILLIAM L. MILLER, WADING RIVER, LONG ISLAND, N.Y.

The first church organized at Wading River was Presbyterian. Shortly after the first meetinghouse was constructed, the "Great Awakening" occurred, and in 1785, the church reorganized as Congregational, which it has remained. It was the second Congregational church in Suffolk County. The first pastor was Rev. Jacob Corwin, who began his service in November 1787. Eventually, a church was built on the north side of North Country Road across the street from its current location. In 1837, a new church was built. The old church was sold to the Hulse family, who turned it into a barn. Zophar Miller traded the land where the church now stands for the site where it once stood. On the right, the church is pictured in the late 1800s; below, in 1913. (CE and JA.)

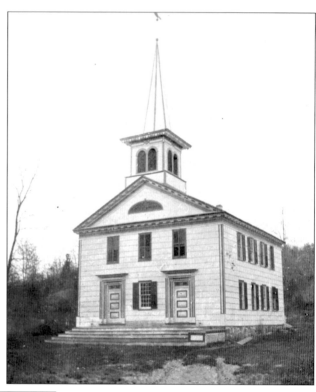

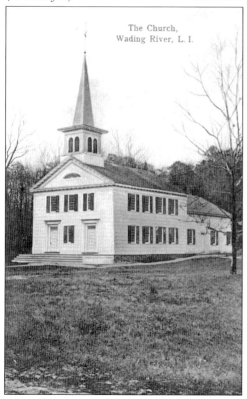

The Church,
Wading River, L. I.

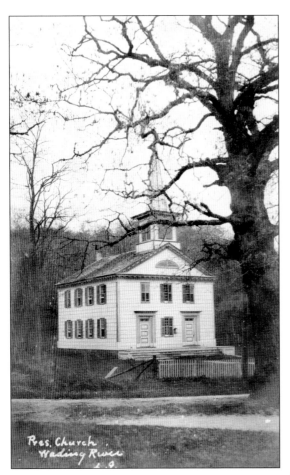

Res. Church
Wading River
L. I.

The church is labeled Presbyterian in the photograph on the left, but it was likely Congregational at the time it was taken. It is correctly labeled Congregational in the photograph below, which also shows the addition at the rear of the sanctuary and the parsonage to the right. The church parlor was added in the early part of the 20th century, and in 1954, the west wing was added to create space for a Sunday school. In 1967, the east wing was added to provide office and meeting space. (CE and JA.)

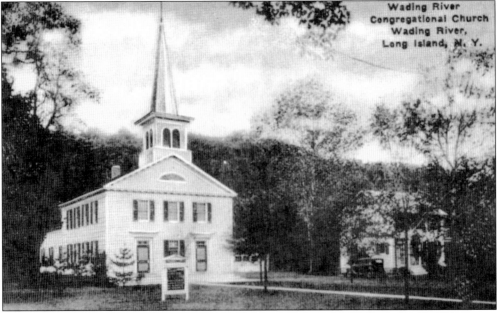

Wading River
Congregational Church
Wading River,
Long Island, N. Y.

In the absence of a Roman Catholic church, masses were held in the Gustave Hurliman home (above), where Mary Hurliman offered space for visiting priests to conduct services. The first mass was held in her home on September 16, 1912. The Greenbrier Inn had allowed Catholic services to be held in the dining room, and Theodora Heatley also opened her home for mass before the church was constructed. In the earliest known photograph (below) of St. John the Baptist Roman Catholic Church, the building is a simple structure without the rectory and later additions. It was built in 1922. (WRHS and SUFFOLKCOHISSOC.)

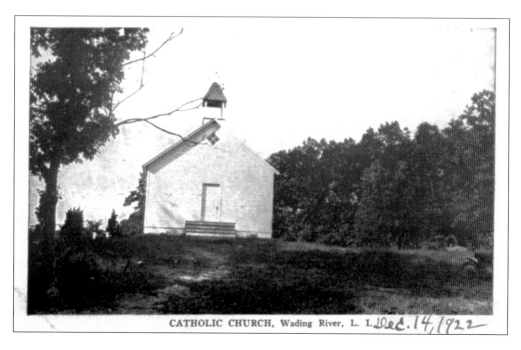

CATHOLIC CHURCH, Wading River, L. I. Dec. 14, 1922

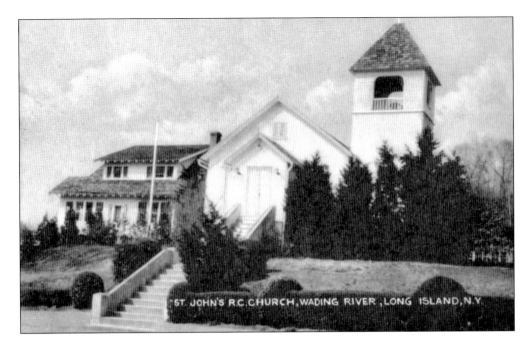

An addition was constructed in 1960 to accommodate the larger summer parish population. The addition could be closed off in the winter when the population was smaller. The parish was originally part of SS. Peter and Paul Church in Manorville, which was established in 1912. The old St. John's was taken down, and in 1997, a new church was built on the site of the old one. In the rear on the right, the parish hall, which houses classrooms for religious instruction, the parish office, and a meeting hall were built in 1974. (JA.)

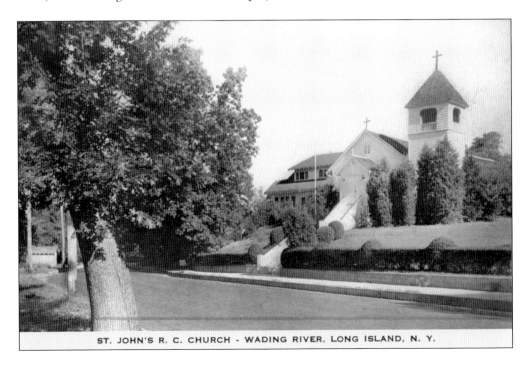

ST. JOHN'S R. C. CHURCH - WADING RIVER, LONG ISLAND, N. Y.

Three

The Camps and Parks
Into the Woods

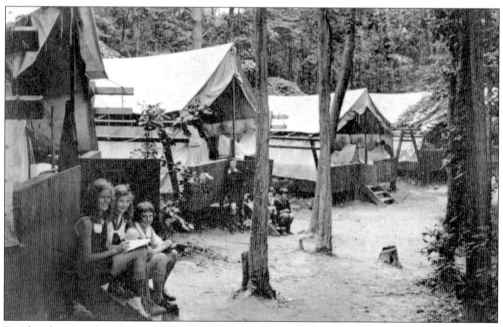

Besides the church camp at Camp DeWolfe, Girl Scouts, Boy Scouts, 4-H groups, Camp Fire Girls, New York State, the Catholic church, and private individuals all established summer camps in Wading River. The girls sitting on the steps to their tent are typical of the many young people who were given the opportunity to spend some time in Wading River. They were happy to be a part of a wonderful experience. (JA.)

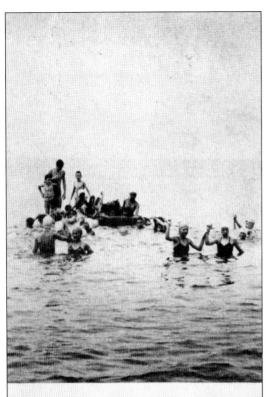

CAMPERS ENJOYING THE SWIM-
MING IN THE LONG ISLAND SOUND,
CAMP DeWOLFE
WADING RIVER, N. Y.

The Episcopal church has a presence in Wading River with a summer camp called Camp DeWolfe. Begun in 1947, it has offered programs for campers during the summer, including swimming and woodland recreation, along with other programs throughout the year. It is one of several camps established in Wading River. The history of the property includes a time when it was used for a counterintelligence program during World War II before it became a camp. (JA.)

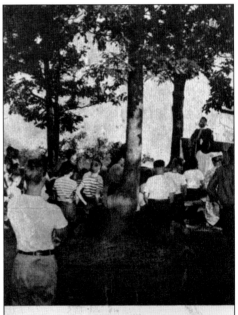

THE EARLY MORNING EUCHARIST
FOR THE STAFF AND CAMPERS
CAMP DeWOLFE,
WADING RIVER, N. Y.

The Steps, Brooklyn Girl Scout Camp, Wildwood Park
Wading River, L. I., N. Y.

The Girl Scouts of Brooklyn established a camp on property in Wildwood State Park. The girls and camp staff had access to the beach via a long stairway from the top of the cliffs. Overlooking the Sound, the camp offered water recreation and a woodland environment for exploration and learning. Campers might be awakened by the horn of reveille to face a day enjoying hikes, crafts, swimming, and other activities. (JA.)

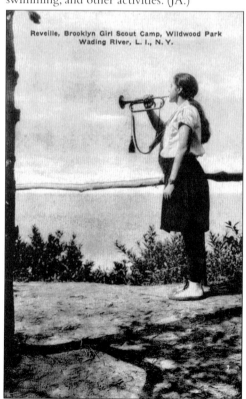

Reveille, Brooklyn Girl Scout Camp, Wildwood Park
Wading River, L. I., N. Y.

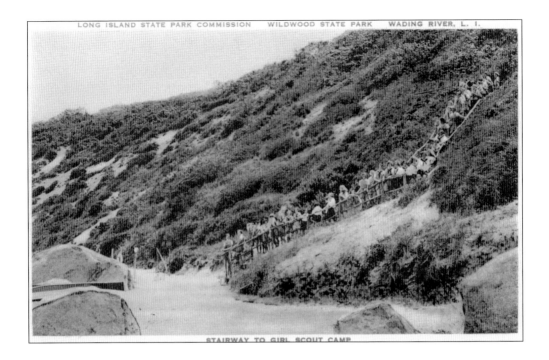

STAIRWAY TO GIRL SCOUT CAMP

The steps from the top of the hill at the camp to the beach were long and ended near a collection of boulders. About 40 campers are on the stairway in this photograph. Note the life ring hanging between two poles beside one of the boulders at the base of the hill. At the top of the hill at the campground, the Girl Scouts salute the flag. The site overlooks the Sound, where they could watch the sunset each evening. (JA.)

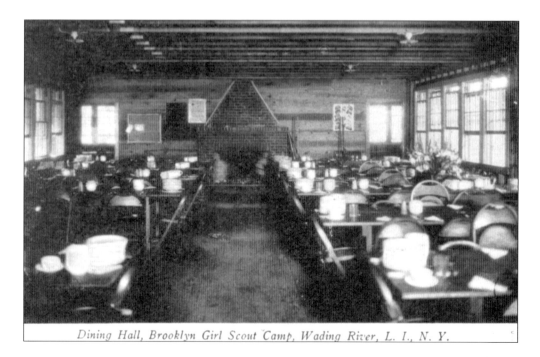

Dining Hall, Brooklyn Girl Scout Camp, Wading River, L. I., N. Y.

The Girl Scout camp at Wildwood had a variety of buildings, bunkhouses, and platforms for tents. One of the buildings housed a large dining hall for the campers with a fireplace at the end. It was used for group activities, music, and probably performances by the Scouts. Other similar buildings had space for group activities, like this one, which was an inviting spot for indoor storytelling, games, and sing-alongs when the weather was uncooperative. On the fireplace mantel is a sign reading "Pemaquid," a place in Maine famous for its oysters, which may have been the name given to that building. (LJ.)

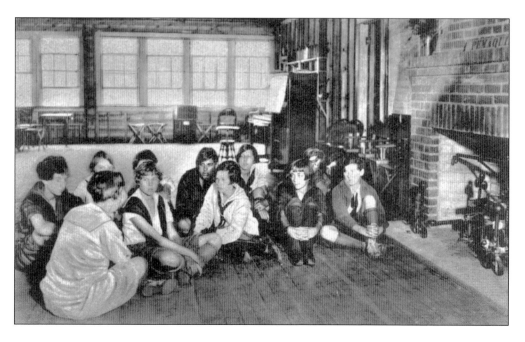

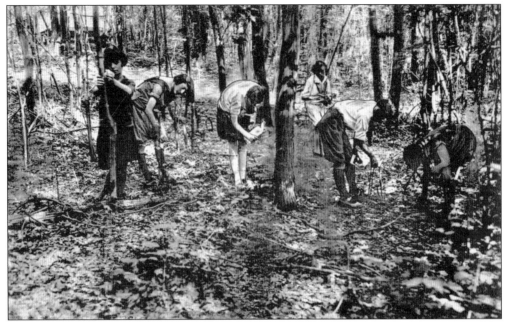

Woodland activities including plant identification, gathering wood for campfires, hiking, and the like were part of the Girl Scout experience at Wildwood. There were many acres of woods to hike and explore with a large variety of native trees and plants as well as birds and wildlife. (JA.)

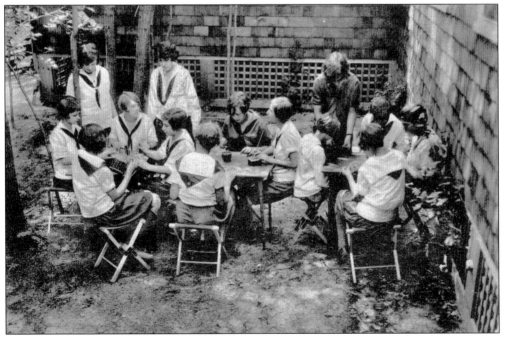

Craft classes have always been a part of Girl Scout activities, and camp crafts were a part of the Wildwood camping experience. Here, the Scouts work outside on their projects under the supervision of their Girl Scout leaders. (JA.)

Camp Grey Beech was the Nassau County Girl Scout camp at Wildwood Park. This was one of several camps at the park. The trails through the woods offered easy hiking paths for the girls as well as vehicle access. The Nassau Girl Scouts Administration Building pictured below was built in an Adirondack style with rustic railings on the front porch. Other cabins and platforms for tents were built in the woodland clearings for the campers. (LJ.)

A Woodland Road. Camp Grey Beech. Wading River, Long Island.

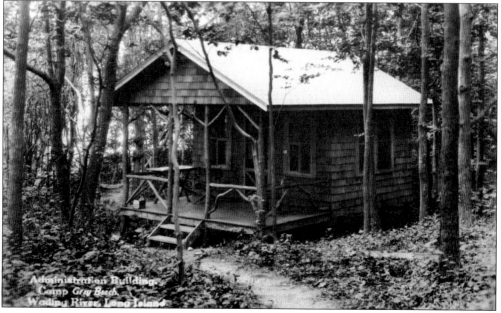

Administration Building. Camp Grey Beech. Wading River, Long Island.

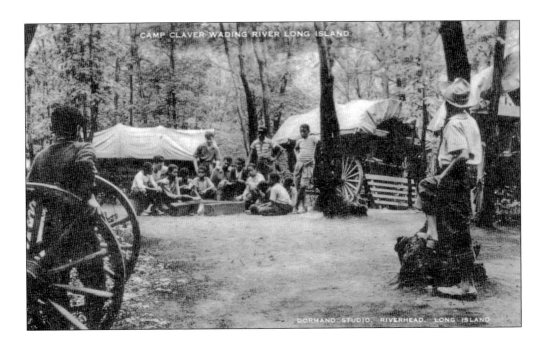

In 1936, Fr. Bernard J. Quinn, who founded Little Flower, established a camp on the orphanage grounds. Called Camp Claver after St. Peter Claver Parish where Quinn was appointed, it offered children from a city environment the chance to experience the rural atmosphere of the woodlands and beach at Wading River. Assisted by volunteers from the Scouting Association of America, the camp began with cabins and tents for the children and land cleared for other camp activities. The campers could experience swimming in the Sound, sleeping in the woods, and playing on the activity fields. (JA.)

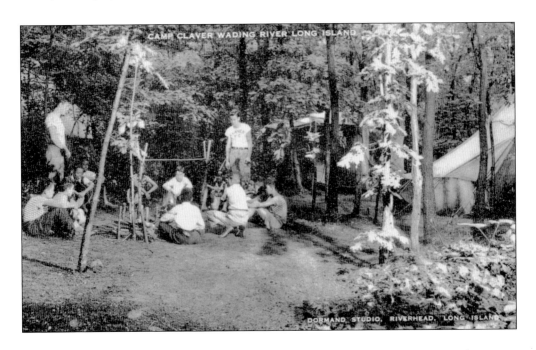

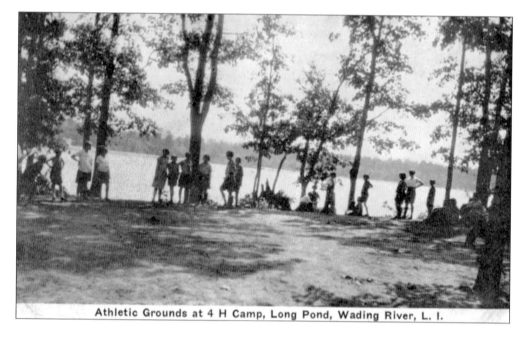

Athletic Grounds at 4 H Camp, Long Pond, Wading River, L. I.

A deep lake just south of the Wading River Railroad station, Long Pond (also known as Lake Panamoka), developed as a summer community where people built cabins around the lake. The 4-H organization took advantage of Wading River's rural environment there as well with a camp at the lake. It offered athletic grounds, as shown in this image, and other camping experiences—much like those provided by the Scouts at Wildwood—only with swimming in the lake instead of the Sound. This 1929 photograph shows the building that was the 4-H camp administration office at Long Pond. (JA.)

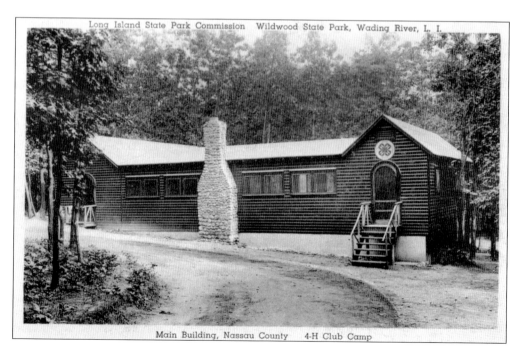

Long Island State Park Commission Wildwood State Park, Wading River, L. I.

Main Building, Nassau County 4-H Club Camp

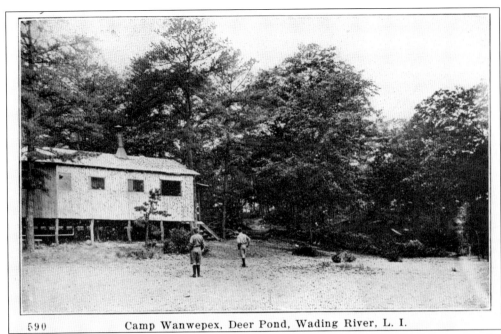

Camp Wanwepex, Deer Pond, Wading River, L. I. 590

Not to be outdone by the Girl Scouts at Wildwood Park, the Nassau County Boy Scouts had a camp at Deep Pond, located between Long Pond and the railroad station. Misspellings aside, Camp Wauwepex at Deep Pond had cabins, athletic grounds, and camping areas. Platforms for tents were built. "Wauwepex" is said to mean "a place of good water," and Deep Pond fits that description well. Situated in the middle of several hundred acres, the lake has some sandy beaches and is good for swimming, canoeing, fishing, and lakeside campfires. Purchased in 1926, the camp has hosted Scouts in all seasons. Camp Newcombe on Lake Panamoka was another Boy Scout camp in the area. (JA.)

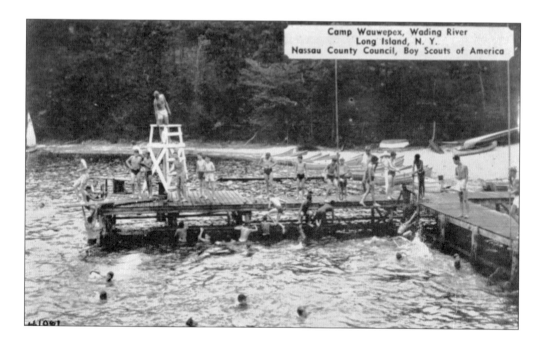

A lifeguard stands watch over active Boy Scouts as they swim and dive off a platform along the beach at Deep Pond. A kettle hole of 30 acres, Deep Pond gives Scouts plenty of room for recreation. Camp Wauwepex is now called Schiff Scout Reservation, after John M. Schiff, an important figure in Boy Scouting. With about 20 buildings, the camp can serve almost 300 Scouts at a time. The platforms (below) are used for tent camping, although cabins are also used. In November 2011, a fire at the camp destroyed Hickox Dining Hall. The Scouts plan to rebuild it. (JA.)

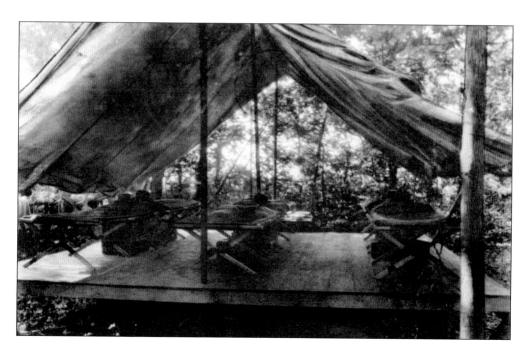

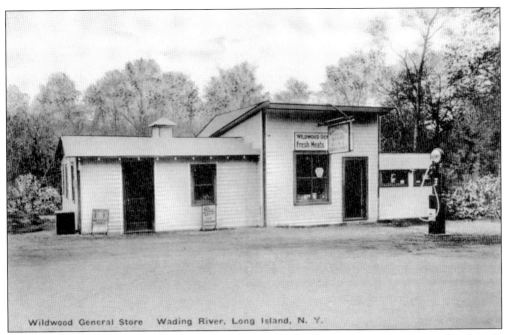

Wildwood General Store Wading River, Long Island, N. Y.

Camping at Wildwood Park was not just for youngsters. Families came to enjoy the rural and rustic atmosphere. To provide supplies to the campers, the Wildwood General Store was established, where campers could buy food, fuel, and other sundries while they camped. For a few weeks in March 1935, the post office was located here. (JA.)

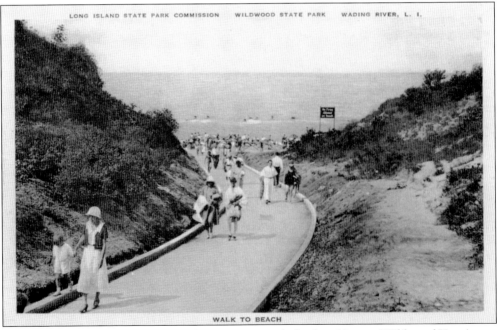

LONG ISLAND STATE PARK COMMISSION WILDWOOD STATE PARK WADING RIVER, L. I.

WALK TO BEACH

A long ramp to the beach from the parking area was made for day visitors to Wildwood. Vacationers made sure to bring the items they needed for the day when they took the walk down, since nobody wanted to have to walk up again until the end of their day at the beach. (JA.)

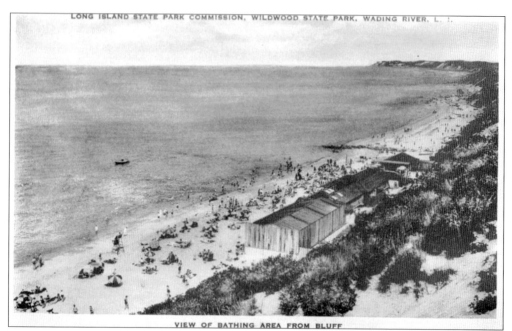

VIEW OF BATHING AREA FROM BLUFF

Beachgoers have a wide beach and calm waters to enjoy at the bottom of the hill, where a bathing pavilion provided shelter, restrooms, and changing areas before the trek up the hill again at the end of the day. The attractive qualities of the site then are the same today, where 600 acres of forest are open for exploration. (JA.)

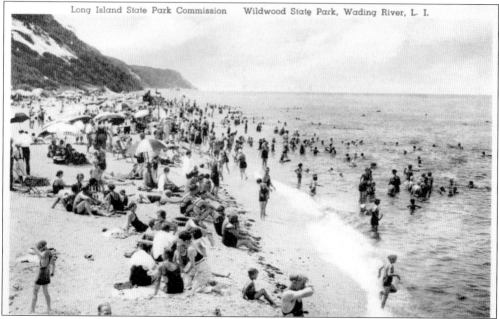

Long Island State Park Commission Wildwood State Park, Wading River, L. I.

A view of the beach at Wildwood in the 1930s shows how popular a site it was—and still is today—for people who want to have vacation time along the North Shore of Long Island. The pavilion still exists, and the campsites, a playground, a barbecue, and picnic areas are still there to be enjoyed by vacationers. The park also offers programs during the summer season, fishing all year, camping from April to October, and cross-country skiing when it snows. (JA.)

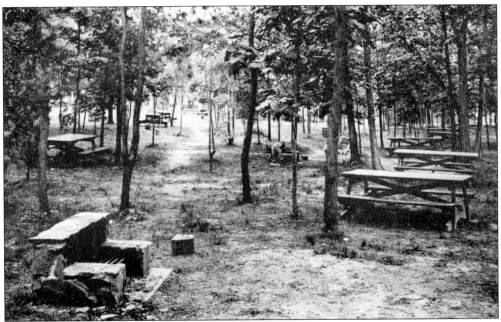

For families wishing to enjoy a picnic or barbecue, outdoor fireplaces and tables were available for visitors of the park. Families could come out for the day to swim, hike, play on the activity fields, and to picnic in the park when they got hungry. The park was an inexpensive place to "get away from it all." (JA.)

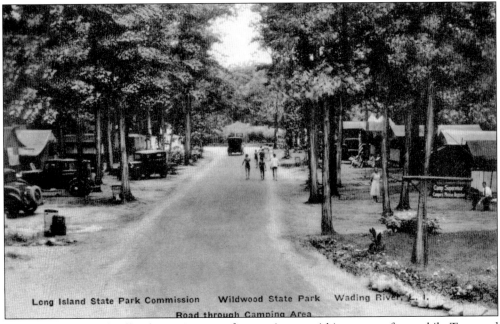

Long Island State Park Commission Wildwood State Park Wading River, L. I.
Road through Camping Area

Wildwood State Park offered camping areas for vacationers wishing to stay for a while. Tents and camping vehicles were used for overnight, weekly, or longer stays in the rural setting. For people in the metropolitan area, this easily accessible place for recreation provided all they wanted: beach, woods, nearby farms, and a relaxed atmosphere for vacation. (JA.)

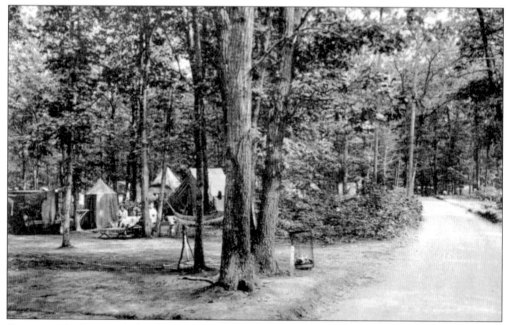

Campers who have settled in for a vacation at Wildwood have their tents set up and their hammock slung for some rest at their campsite. Some families claimed the same spot year after year, making and developing friendships they could renew each summer or continue to enjoy throughout the year. (JA.)

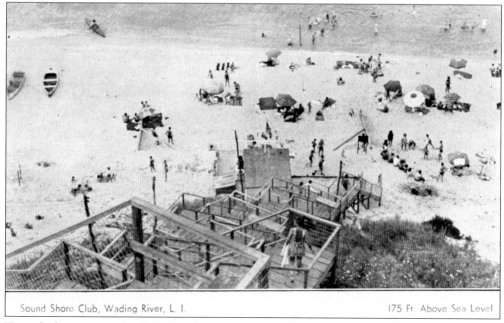

Sound Shore Club, Wading River, L. I. 175 Ft. Above Sea Level

Towards the eastern side of Wading River is a colony of summer homes called the Sound Shore Club, where five camping families from nearby Wildwood bought land in 1938 and formed their own campsite. Noted sculptor Begni Del Piatta once owned the property. Today, the site has evolved into a shareholders corporation. Their steps down to the beach can be seen in this image. (LJ.)

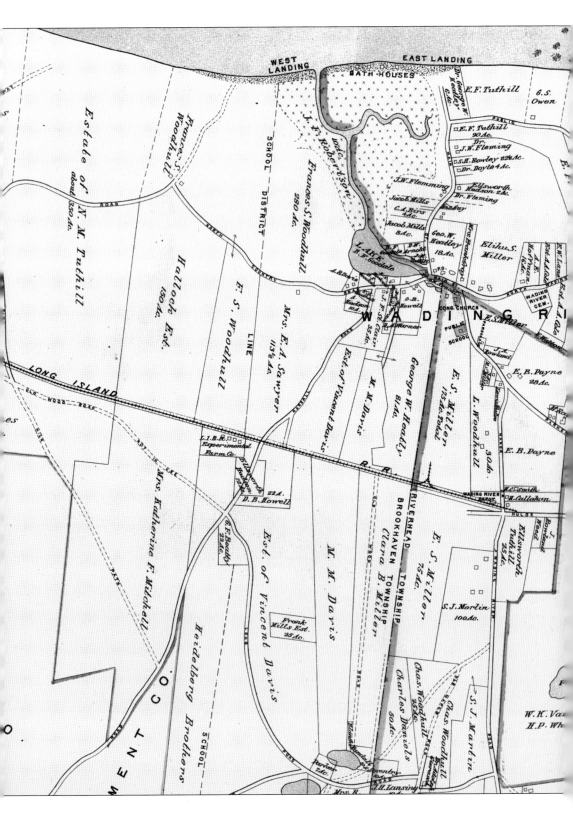

WEST LANDING

EAST LANDING

BATH HOUSES

E.F. Tuthill

Dr. George W. Keasley 6 Ac.

G.S. Owen

Estate of N. M. Tuthill about 350 Ac.

E.F. Tuthill 90 Ac.

Dr. J. W. Fleming

G.S.H. Rowley 22¾Ac.

Dr. Doyle 4 Ac.

Frances S. Woodhull

J.W. Flemming

Ellsworth Hulson 2 Ac.

Dr. Fleming

Jacob Mills

Jas Ivey

R.N. Lane 10½ Ac.

A.F. Hoffman 16¾ Ac.

Jno. Robertson

G.A. Birs 4 Ac.

Jacob Mills & Ac.

Geo. W. Headley 18 Ac.

A.F. Hoffman

Frances S. Woodhull 280 Ac.

Elihu S. Miller

A.B. Davis

L. Aig E. B.F. Goodale

B.F. Goodale Charlie Arnold

D.M. Howell

SCHOOL DISTRICT

E. S. Woodhull

Hallock Est. 150 Ac.

Mrs. E.A. Sawyer 113½ Ac.

J.P. St. Clair 35 Ac.

O.B. Howell

E. Hudson 10½ Ac.

J.P. St. Clair

WADING RIV

CONG. CHURCH

WADING RIVER CEM.

E.S. Miller

LINE

Est. of Vincent Davis

I. Warner

PUBLIC SCHOOL

J.A. Rowland

E. B. Payne 28 Ac.

George W. Headley 81 Ac.

E. S. Miller 125 Ac. Total

L. Woodhull

LONG ISLAND

M. M. Davis

30 Ac.

E. B. Payne

Mrs. Katherine F. Mitchell

L.I.B.R. Experimental Farm Co.

H. C. Smith

H. Callahan

WADING RIVER DEPOT

BROOKHAVEN TOWNSHIP RIVERHEAD TOWNSHIP

HULSE

J. Rowland Wood

Ellsworth Tuthill 25 Ac.

22 A.

D. B. Howell

R. R.

E. S. Miller 75 Ac.

G.F. Beatly 23 Ac.

MENT CO.

Est. of Vincent Davis

M. M. Davis

Clara B. Miller

S. J. Martin 100 Ac.

Heidelberg Brothers

Frank Mills Est. 25 Ac.

Charles Daniels 50 Ac.

Chas. Woodhull 25 Ac.

Chas. Woodhull

S. J. Martin

W. K. Va H. P. Wh

SCHOOL

Parlor ½ Ac.

J.H. Lansing

74

Wading River of 1909 had the amenities of a railroad station, post office, and general store, as is notated on this map. Published by Belcher–Hyde, it shows the various property owners within the Wading River community and the locations of homes and businesses in the area. (JA.)

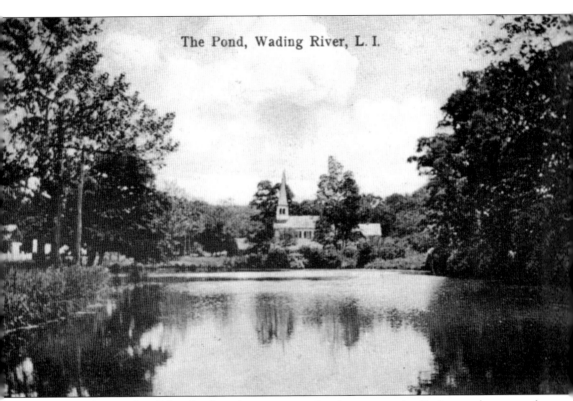

The Pond, Wading River, L. I.

The pond in Wading River has long been a center for the community. Businesses, homes, and the church cluster around it. There was just one pond at the time of this photograph where there are now two—Zophar Mills Road bisected the pond in the mid-20th century. The scene of the church across the ponds is not so different today as it was in this early 1900s photograph. There are flowering cherry trees lining the roadway, a fence, and some benches. The ponds are still attractive to waterfowl and to people who like to feed the birds or sit on the benches. Fourth of July parades once traveled past it, and since 1994, it has been the focal point for the Annual Duck Pond Day, where the community and ponds are celebrated with a parade, music, vendors, and food. (JA.)

Four

1895
THE WORLD ARRIVES AT SHOREHAM'S DOORSTEP

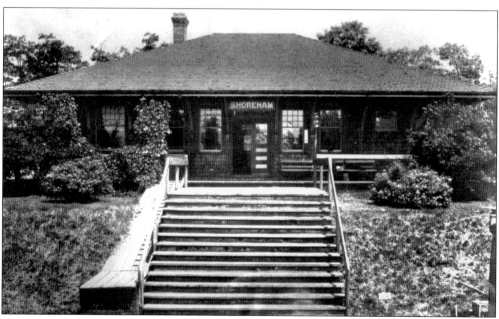

The arrival of the railroad in 1895 linked Shoreham to the world and heralded the area's development. Shoreham's second railroad station was built around 1900 near the laboratory of inventor Nikola Tesla. Shoreham Village historian Ivy Frei gave a talk in 1958 to the Shoreham Garden Club, saying Tesla "was instrumental in having sent in the finest Philadelphia front brick for the fireplace, and when the station was completed, it was considered one of two finest on Long Island. Southampton was the other." (JA.)

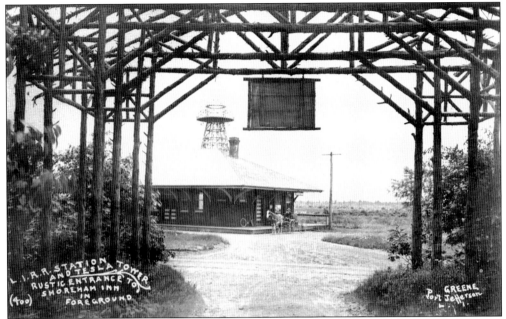

This photograph provides a southeasterly view of the 1901 Wardenclyffe LIRR Station with the Tesla Tower in the background. The view is framed by the "Rustic Entrance" to the Shoreham Inn. Business partner Charles L. Flint had introduced Nikola Tesla to James S. Warden, and Warden provided Tesla with 200 acres to build his laboratory near Warden's planned community. The photograph below shows Tesla's Experimental Station, a brick building designed by famed architect Stanford White. The station is still standing and efforts are afoot to save this architectural gem as a science museum. To its right is another view of Tesla's 187-foot transmitting tower. The tower was designed and constructed by White's associate, W.D. Crowe of East Orange, New Jersey. (SUFFOLKCOHISSOC.)

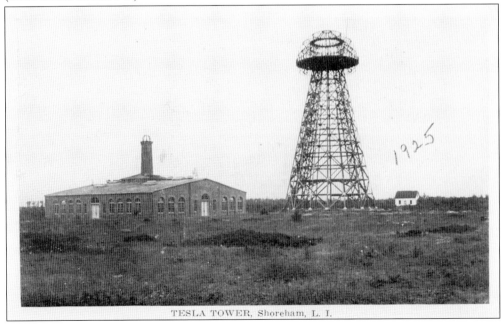

TESLA TOWER, Shoreham, L. I.

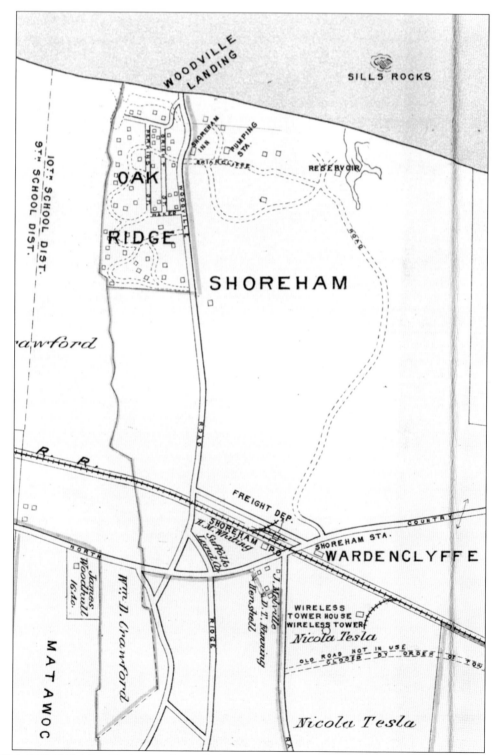

This 1909 E. Belcher Hyde Map shows the location of the "Wireless Tower House, Wireless Tower" and Shoreham Railroad Station shown on the opposite page. (JA.)

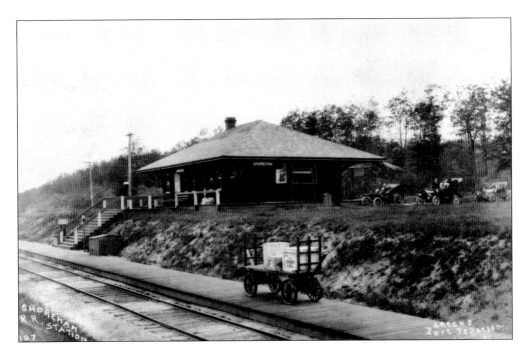

These are two views of the Shoreham train station. The freight wagon and motorists are awaiting a westbound train back to the city. Shoreham had regular train service until October 1928, when the LIRR terminated its run at Port Jefferson and ran a small gasoline shuttle car (known to locals as "the Dinky") on the Wading River line. In October 1938, the line was abandoned completely, and the train station was then demolished. One of the station's original "Shoreham" signs was salvaged and hangs above the dance floor of the Shoreham Village Hall. (KB and SVA.)

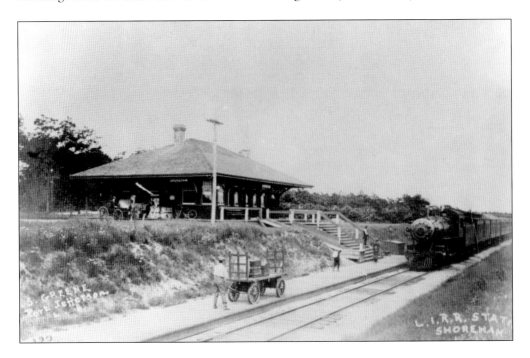

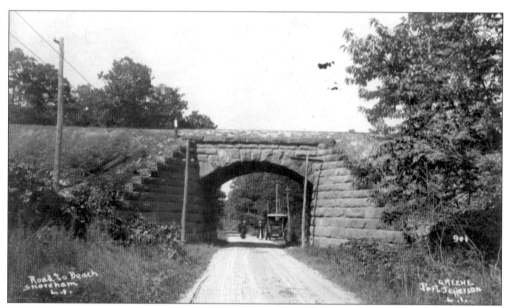

This railroad bridge over Woodville Road has a one-lane underpass and was sturdily built by Italian stonemasons using huge, perfectly interlocking brownstone blocks with no visible mortar. It had a twin spanning Hallock Landing Road, Rocky Point, which was demolished after the Wading River line was abandoned. The Shoreham bridge is much beloved by Shorehamites as a symbolic passageway from the hustle and bustle of the busy world to their quiet little sanctuary. The photograph below shows the bridge still in excellent condition on the occasion of its 100th anniversary party on August 14, 1995. The celebratory crowd included longtime residents Rockwell Colaneri, Harry and Jean Laurencot, Robert Oliver, and Paul Vermylen, all of whom had ridden the train to Shoreham prior to the discontinuance of rail service in 1938. It is local convention that a village-bound motorist entering the underpass has right-of-way over one departing. (LB and SVA.)

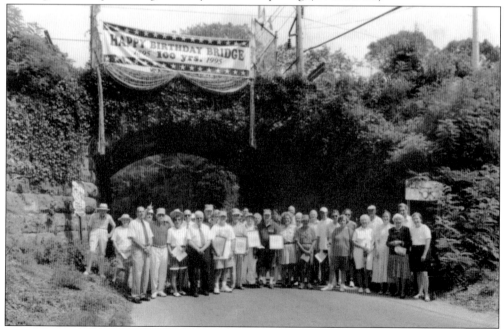

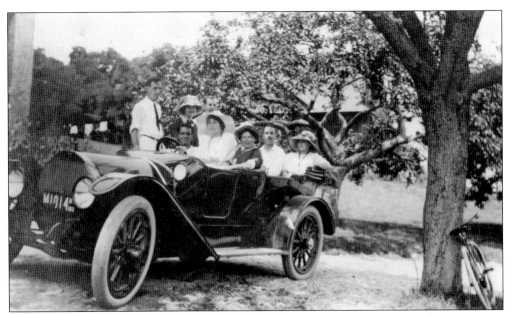

These photographs' caption says, "July 1913. Speech of the Cosmos Boys at a house party at Varians." Alfred Varian, then his son Jack, and succeeding owners of this house have each year generously and patriotically dispensed free crepe paper and American flags from their gazebo on Wardencliff Road to Shoreham children, so they might decorate their bicycles in high style for the big parade each Fourth of July. In this photograph, the arrival of a large party in an early motorcar illustrates the importance of both the train and the automobile in Shoreham's development. It was around 1913 that "the State Road" (25A) was cut through to Shoreham, allowing easier access from New York; indeed, the need to pave Shoreham's own steep, muddy streets was what spurred incorporation as a village in 1913. (LGK.)

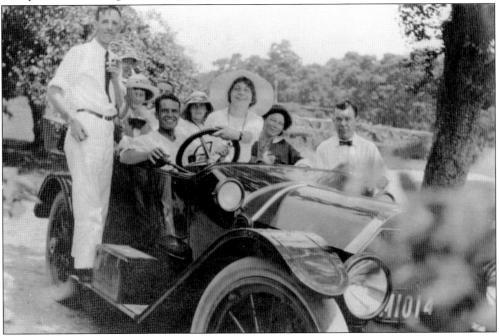

Five

THE SHOREHAM INN
ARRIVAL OF THE "IN CROWD"

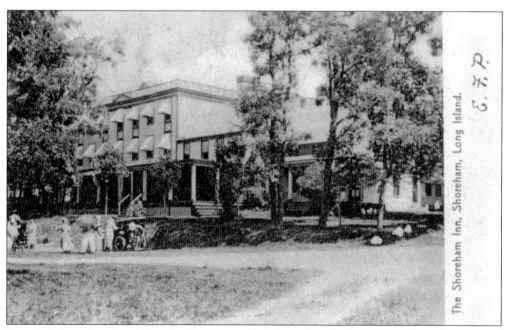

James Warden, Shoreham's first developer, arrived in Shoreham in 1894, just before the arrival of the railroad. He began developing the seaside summer resort Wardenclyffe at what had been called Woodville Landing, where Woodville Road ran all the way to the beach. The resort opened in 1900 and centered on the inn at the corner of Woodville and Briarcliff Roads. (LB.)

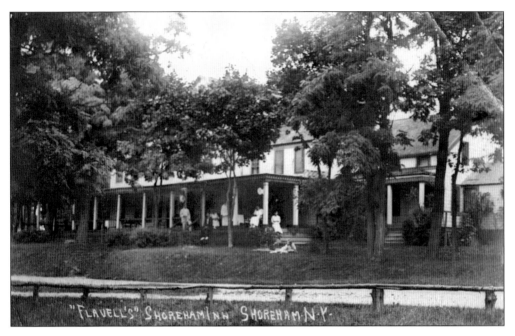

Here are more views of Shoreham's first inn, known variously throughout the years as the Wardenclyffe Inn, the Shoreham Inn, and Flavell's Shoreham Inn (J. Flavell was the innkeeper from 1919–1929). It was originally an early 1800s farmhouse owned by Elbert Woodhull and his family. The photograph below toward the southeast shows the north side of the inn and the beginning of Locust Street (left foreground), now abandoned, going off to the east. It ran behind the Shoreham Inn and its icehouse and powerhouse (now a private residence) before turning south. Its location can be seen on the 1917 map on pages 124 and 125. Its final 100 yards to Briarcliff Road still exists as a private road. (LB.)

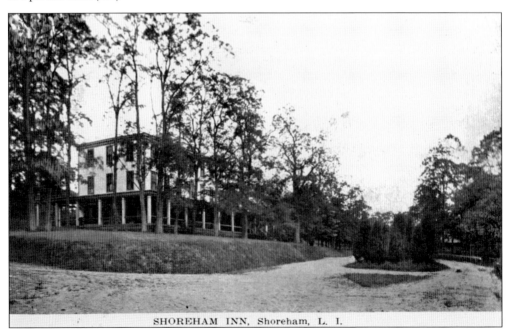

SHOREHAM INN, Shoreham, L. I.

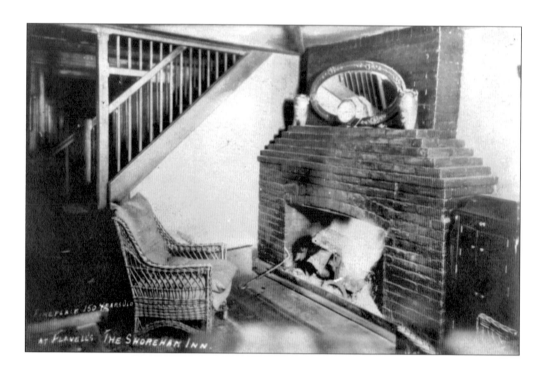

The top photograph is an interior view of the Shoreham Inn and shows its cozy lobby and hearth. The inn closed after the 1929 season and was then demolished. The photograph below shows Briarcliff Road running downhill and west toward its intersection with Woodville Road and Barton Road (now Gridley) in the distance. On the left is an apple and peach orchard that James Warden had cultivated. It is today the site of the village tennis courts and ball field. (JA and LB.)

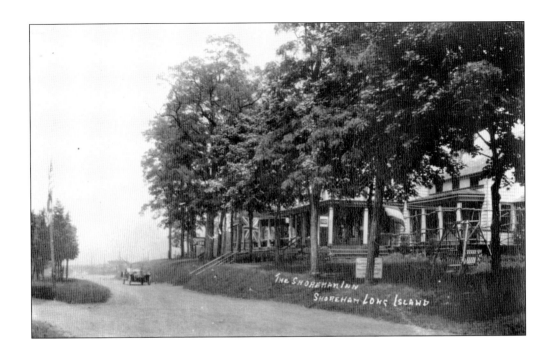

This is a view from Woodville Road looking north toward the Sound, with the Shoreham Inn on the right and the Frances Warden Oval on the left in the center of the entrance to the Shoreham Country Club and beach. Below is a later view of the Warden Oval showing the commemorative plaque dedicating it to Frances Upham Warden, wife of James Warden and a founding member of the Shoreham Garden Club. The Warden Oval has always featured beautiful plantings. (MAO.)

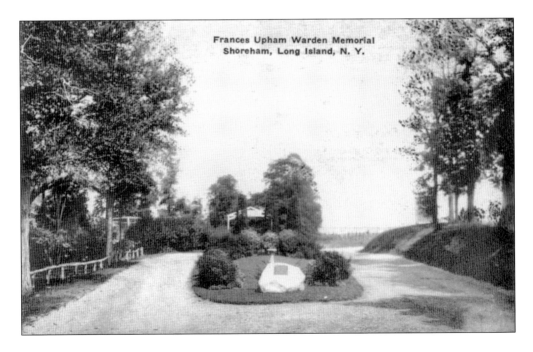

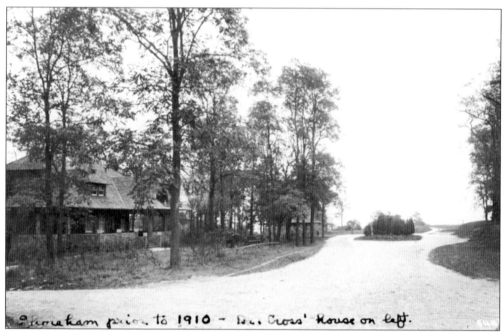

To the left of the Warden Oval was the residence of Belle Vorhees Aldridge, a female physician. The home was later owned by the Muller family. In the distance and obscured by trees is the residence of Randall D. Warden, son of James S. Warden and Shoreham's first historian. Randall, an ardent suffragist, summered in Shoreham but lived most of the year in Newark, New Jersey, where he was a director of physical education for the city of Newark. In 1917, the Newark Normal School of Physical Education and Hygiene was established with Warden elected president. (MAO.)

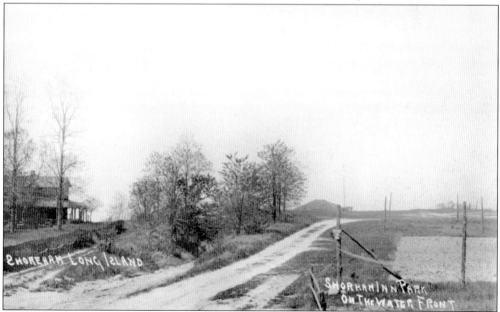

This is a northern view from the Shoreham Inn showing its tennis and croquet courts. The roof of the bathing pavilion is just visible in the center. To the left is the Log Cabin, which served as the first Shoreham Country Club. (LB.)

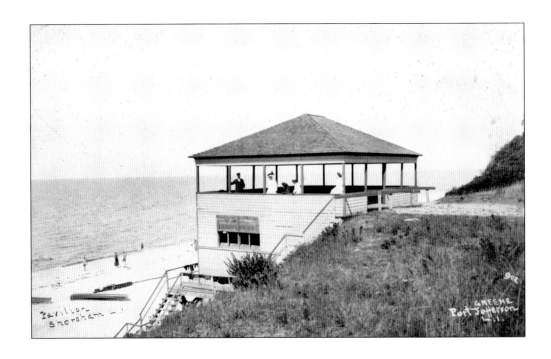

The beach pavilion was boldly built into the face of the bluff around 1900 and situated north of the Shoreham Inn. It featured an observation deck, changing rooms, and stairs to the beach. It stood until it was lost to storms and erosion in the early 1920s. (LB.)

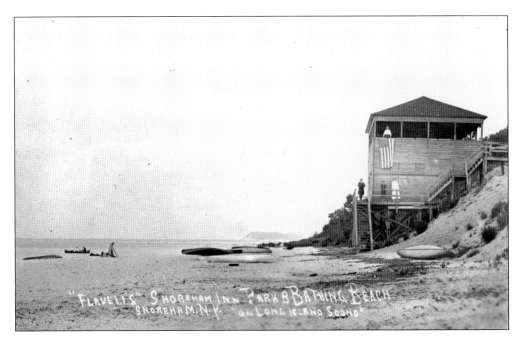

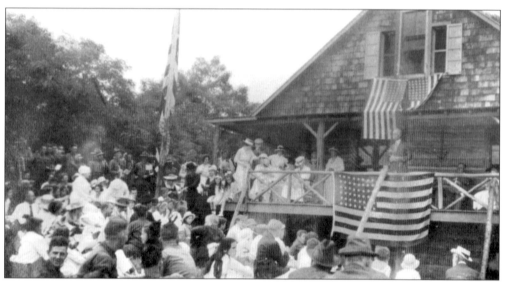

This photograph, taken by the Log Cabin, shows the wartime July 4, 1918, festivities. The noted female speaker, Baroness Frances Huard, addressed the crowd, which included soldiers visiting from nearby Camp Upton (now Brookhaven National Laboratory). Some of the fiercest fighting of World War I had occurred around Huard's home in France. Village historian Randall Warden noted that "during World War I and World War II, the ladies of the village set up a canteen at the club for soldiers at Camp Upton. They provided homemade cakes and pies as well as cigarettes and bathing suits for the boys. On Fourths of July, races and other athletic events were held for their amusement." (LGK.)

This c. 1910 photograph shows Ada Sherman (right) with her three boys and an unknown woman. The eldest son, Wesley, went on to serve as Shoreham's constable and real estate agent from a small office on Woodville Road. In the background is Shoreham's first country club, the Log Cabin, with gullies on both sides spanned by footbridges. At the time, Woodville Road extended to the beach through the leftward gully. (SVA.)

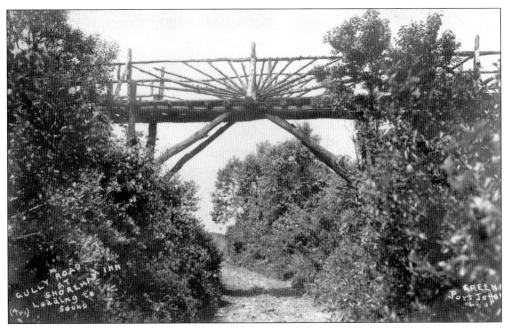

This is a sea-facing view showing Woodville Road (Gully Road) descending to the shore under a locust log footbridge, located near the current site of the Shoreham Village Hall. The photograph below is another view slightly farther down showing Woodville Road ending at the Long Island Sound. From 1840 through the 1890s, teams of horses hauled wagonloads of locally cut cordwood down Woodville to the beach. They would then be loaded at low tide onto waiting sloops and schooners for shipment to New York City and to the large brick kilns at Haverstraw on the Hudson. (MAO.)

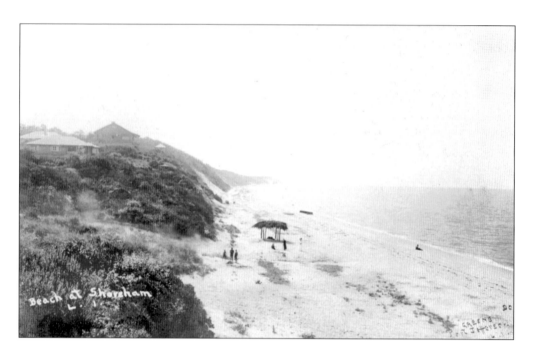

Pictured is an early westward view from the bluff east of the Shoreham Country Club. The house on the left was owned by noted American playwright and theater critic Channing Pollack and later by the Muller family. To its right is the Barnes cottage, which was later turned and moved back from the bluff. On the beach, folks back then were sensibly mindful of the sun—note the shelter with the thatched roof. These shelters abounded in Shoreham and Wading River at the time. The photograph below shows the popularity of canoes at the time. The Barnes cottage is again pictured perilously close to the precipice. (LB and MAO.)

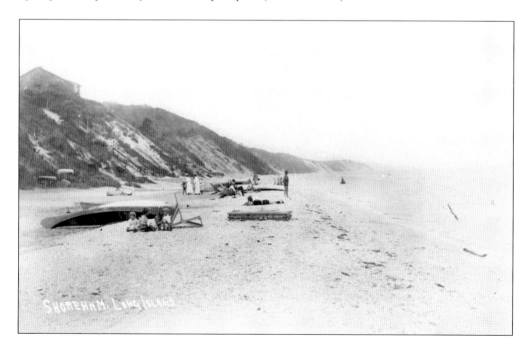

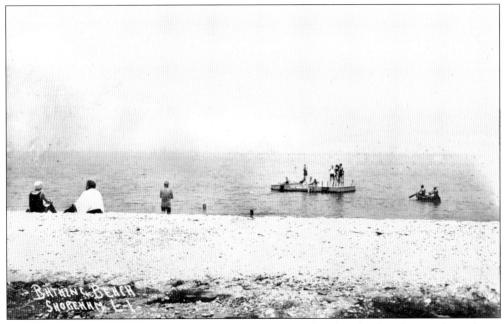

This is an early view of canoers and bathers at Shoreham Village beach. Shorehamites have always enjoyed their raft. (MAO.)

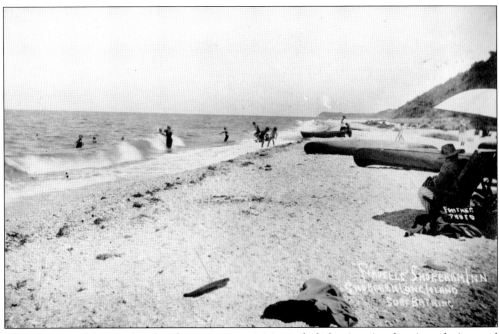

What does one do at the beach? Then, as now, activities included swimming, boating, playing, and just relaxing. In the distance, vegetation at the toe of the bluff marks where fresh water comes close to the surface. The availability of fresh surface water at Woodville Landing encouraged its early development. (LB.)

This 1920s view of the beach depicts a bathhouse and beach chairs. Sills Gully (below) lies just east of Shoreham Village. In 1900, there were brick kilns, clay mixers, brick cutters, drying yards, and large sheds the entire length of this ravine. After a few years of operation, the Wardenclyffe brickyard was forced to close. Despite an investment of a great deal of capital and the production of several hundred thousand bricks, the clay lacked sufficient cohesiveness to be manufactured by machinery. Although handmade bricks were superior in quality, they were much more expensive and could not compete with bricks being made by machines elsewhere. In 1934, Randall Warden remembered that it was an exciting place to visit at night, with "the glowing red hot brick and the flames from the burning fires making the view out on the water a mysterious phantom world." (MAO and SUFFOLKCOHISSOC.)

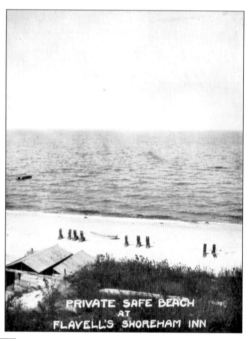

PRIVATE SAFE BEACH
AT
FLAVELL'S SHOREHAM INN

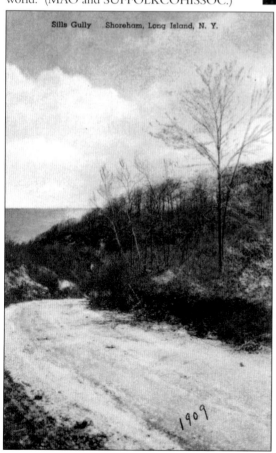

Sills Gully Shoreham, Long Island, N. Y.

1909

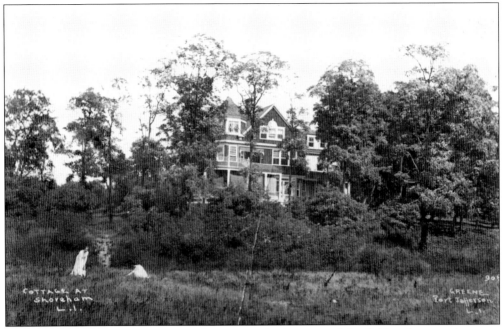

The 1901 Millard home was a magnificent Victorian just east of the field and courts that were north of the Shoreham Inn. Samuel H. Millard was a partner with Warden in the Wardenclyffe Company. After Millard died in 1913, Mary Millard stayed on with her daughter and son-in-law Jason Chapman. Chapman bought the new Woodville Store from Hapgood's Oak Ridge Company in 1910 and served as its first proprietor. Sadly, the Millard home burned to the ground in the 1920s in Shoreham's first major fire. The 1920 photograph below is looking east from the bluff that is west of Woodville Landing. Structures pictured from left to right are the beach Pavilion, the Millard House, the newly constructed Shoreham Country Club, the Stanton–Bailey house, and the 1897 Randall Warden home, which was later moved a quarter of a mile down Woodville Road to its current location. (KB and LB.)

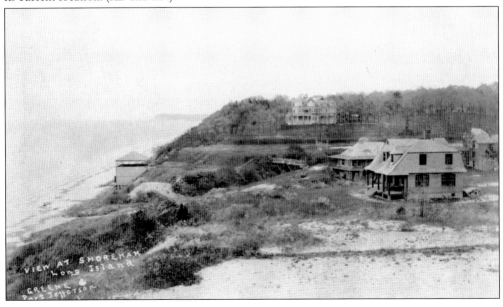

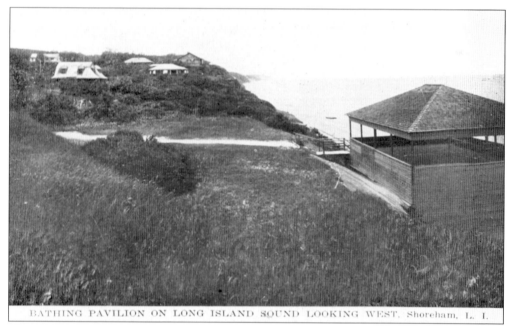

BATHING PAVILION ON LONG ISLAND SOUND LOOKING WEST. Shoreham, L. I.

In 1934, the Beach Pavilion in the foreground was described by Randall D. Warden in the *Shoreham Scribe*: "There was a big dancing floor 40 square feet and in the days when the Shoreham Inn was gay and prosperous, the elite spent many happy hours either tripping the light fantastic or quietly gossiping in its comfortable rockers. Underneath the observation floor were 16 bath houses." (LB.)

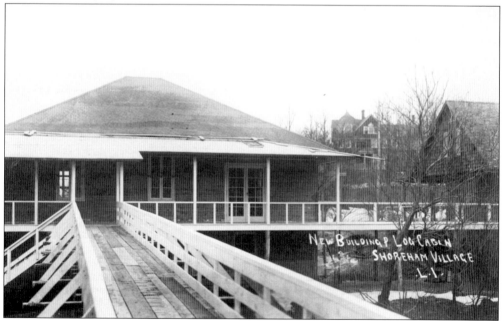

A spring 1919 photograph shows the completion of the construction of a new country club. The bridge in the foreground spanned the gully west of the clubhouse and stood until demolished in the 1970s. The original country club, the Log Cabin, is still standing on the right but was soon demolished. The Millard home is visible in the distance. (MAO.)

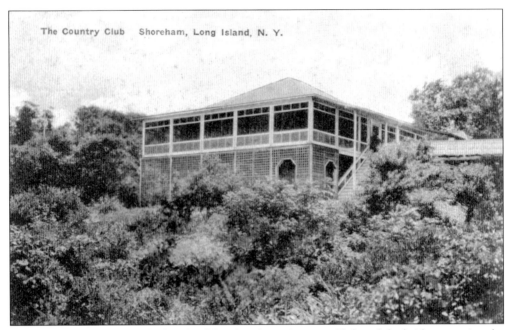

The Country Club Shoreham, Long Island, N. Y.

This is an early view from the beach of the Shoreham Country Club and the bridge spanning the gully to the west. (LB.)

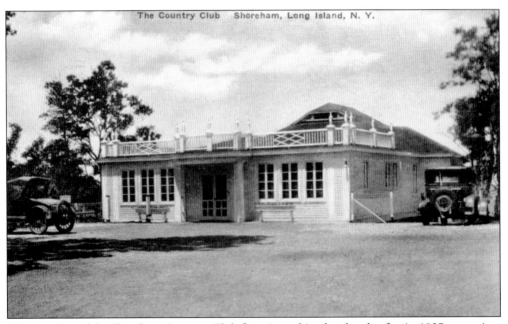

The Country Club Shoreham, Long Island, N. Y.

This is a view of the Shoreham Country Club from its parking lot shortly after its 1935 expansion, including construction of an elegant south wing that included a lounge, kitchen, and grand entranceway. It was designed by noted Shoreham architect George Beatty, who went on to be elected Shoreham's mayor and the Shoreham Boat Club's commodore. (MAO.)

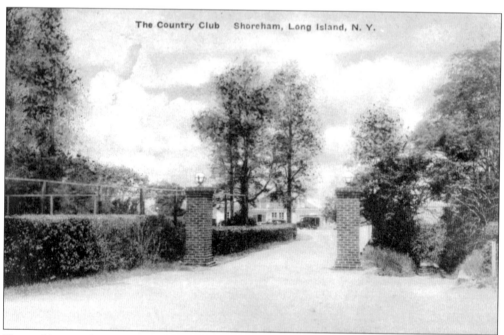

The Country Club Shoreham, Long Island, N. Y.

Pictured is an early view of the entrance to the Shoreham Country Club. Although the clubhouse burned down in 1987 and was replaced with a new village hall in 1990, the original pillars and entrance remain. (MAO.)

"The Outlook"
Shoreham, Long Island, N. Y.

A paved beach path just west of the Shoreham Country Club still exists today. It was renamed Bud Siegel's Beach Lane in 2008 to honor longtime resident and World War II hero Ernest T. "Bud" Siegel. (LB.)

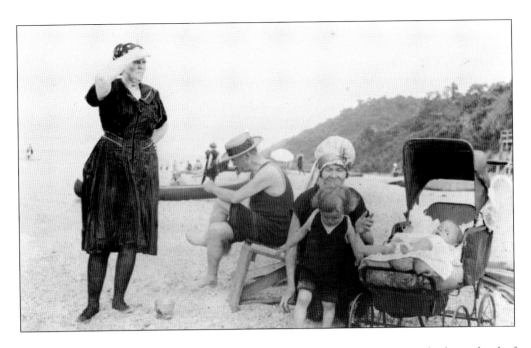

This is a Shoreham Village beach scene taken on July 12, 1917, looking east. The lower level of the beach pavilion, partially visible to the far right of the photograph, offered 16 changing rooms where ladies would put on bulky knit woolen bloomers and bathing costumes. The photographs show that beachgoers of the time were both modest and sensibly cautious about the sun. In addition to the protection offered by large bathing suits, both women and men wore hats, such as the classic men's straw hats of the time. Note also the shade on the baby carriage. Canoes were the watercraft of choice, as seen here and elsewhere in this book. (LGK.)

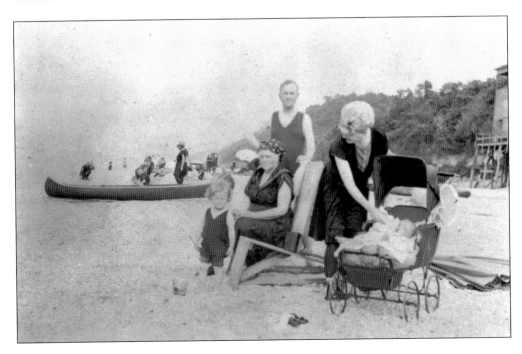

Six

A Dream Realized
Hapgood's Bungalow Colony

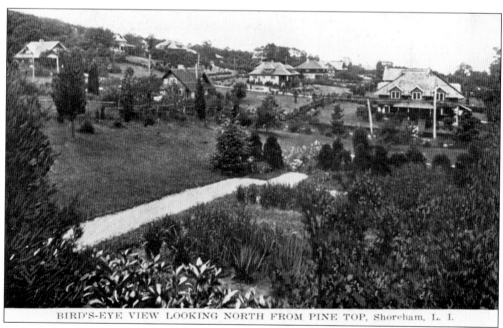

BIRD'S-EYE VIEW LOOKING NORTH FROM PINE TOP, Shoreham, L. I.

This northward view from the hilltop home of Tully Marshall and Marion Fairfax shows the old village shortly after its construction (1906–1910) by Herbert J. Hapgood and his Oak Ridge Company, which took over Shoreham's development after James Warden's 1906 death. According to the *Brooklyn Eagle*, Hapgood built "80 high class bungalows ranging in price from $3000 to $6000, sold to some of the best people in Manhattan and Brooklyn." (MAO.)

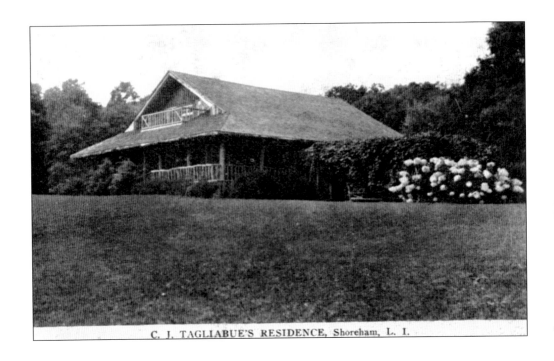

C. J. TAGLIABUE'S RESIDENCE, Shoreham, L. I.

This is the home of Charles J. Tagliabue, who made his fortune by manufacturing precision scientific instruments in Brooklyn. Tagliabue financed the construction of Shoreham through his son-in-law Hapgood. The home is marked with a "1" in the 1917 map on pages 124 and 125. Below, the unusual bench and long staircase were located on Perkins Road (now Tagliabue Road) and led up to the Tagliabue house. (LB and JA.)

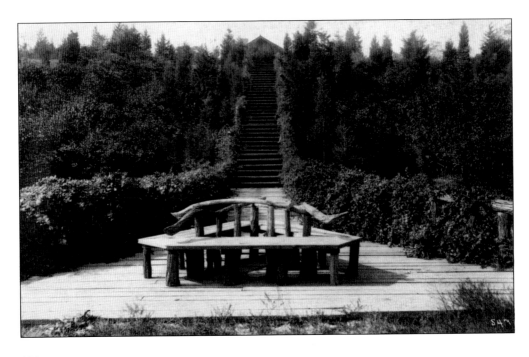

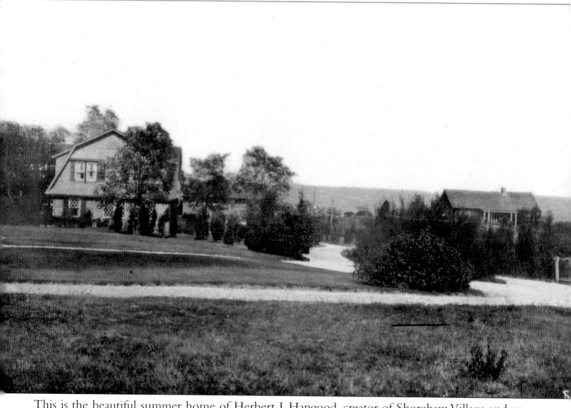

This is the beautiful summer home of Herbert J. Hapgood, creator of Shoreham Village and co-creator of Shoreham Estates. It was his vision—with the financial backing of his father-in-law, Charles J. Tagliabue, a Brooklyn manufacturer—that transformed Wardenclyffe, a small community with a hotel and a few summer homes, into the thriving summer colony of the early 1900s. In 1911, while still completing Shoreham Estates, Hapgood began work on a New Jersey lakeshore development called Mountain Lakes, where he eventually built 500 grand homes, many of which were reminiscent of their Shoreham counterparts. He is still revered there to this day. Hapgood died in 1929, but his widow, Ethel, occupied this home until her death in 1969. Their descendants lived in Shoreham until the 1970s. (SVA.)

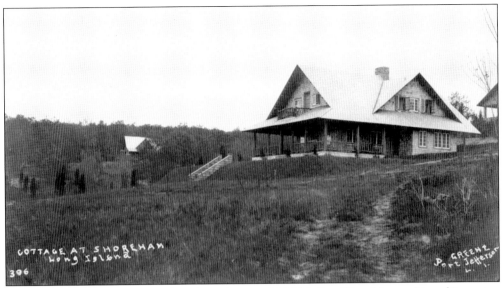

In the foreground is the 1908 Perkins Street home of G.H. Hulin of Brooklyn, cashier of Exporters and Traders Bank. The 1909 home in the background was owned by Dr. Elizabeth M. Sturgis, "whose home among the trees was a bird sanctuary," as Randall Warden described in 1934 in the *Shoreham Scribe*. She shared this home as well as a Brooklyn medical practice with doctors Anna Garnier and Elizabeth Sweet. Doctor Sturgis and Doctor Garnier gave medical relief in France during World War I with the American Red Cross. Holton Road was renamed Sturgis Road in her honor. (LB.)

The 1907 "Mushroom" was the summer home of George L. and Cora Wright. This home is located on the 1917 map high on the hill, and it would have had wonderful views and glorious breezes from the Sound at the time. George L. Wright died in Shoreham, his summer home, in 1909 at the age of 94. He was a pioneer in the fine writing paper industry and invented a machine for ruling letter paper. (MAO.)

This charming waterfront summer home above "the Steppes" was built in 1897 for Randall D. Warden. In the late 1890s, famous suffragist Elizabeth Cady Stanton (1815–1902) lived in this home with her secretary and wrote her book *Eighty Years and More*. For two years, this home became the summer capital of the women's suffrage movement. Randall Warden wrote in 1936, "Every small child that came to Mrs. Stanton's door was taught to say, 'I believe in votes for women.' " (LB.)

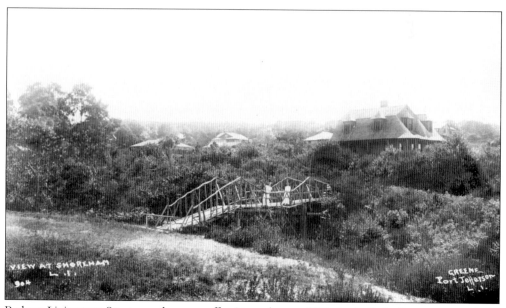

Robert Livingston Stanton, a lawyer, suffragist, and son of Elizabeth Cady Stanton, owned the striking home in the foreground of the photograph above until 1921. His sister Margaret L. Lawrence also owned land in the village and was a suffragist. For many years, she was head of the departments of physical training at Teachers College, Columbia University, 1891–1901, and St. Agatha School, New York City, 1902–1910. (MAO.)

Pictured are two views of the Rumler homestead, which is located in the bend of Flint Street on the 1917 map. Robert Rumler, a silk manufacturer in Brooklyn, purchased this home from the Oak Ridge Company in 1909. Johanna Rumler wrote to a friend in Brooklyn on July 30, 1919, "I am sorry you did not have such a fine day as we have today when you were here, clear, cool and plenty of sunshine. The rabbits, sparrows and cat birds enjoying their mid-day meal right near me." On July 13, 1921, she wrote again, "It is awfully damp out here and hardly any sunshine, so everything is wet and sticky." This was pre air-conditioning, and current villagers without it can relate to these sentiments, which are a downside of living by the water. (MAO.)

This is a rear view of the hilltop Sturgis cottage on Holton Road (later Sturgis Road and then Beatty Road) in Hapgood's Swiss chalet style. Architect George Beatty and his wife, Heloise "Bunny," owned the home from the 1930s to the 2000s. Beatty extensively modified the cottage with a garage and, atop it, a breezeway and porch high up in the treetops. (LB.)

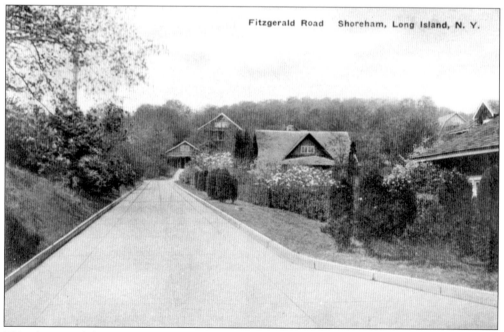

This photograph looks west up Fitzgerald Road, named for Judge Fitzgerald. Note another house on the right in Hapgood's classic Swiss Chalet style. (LB.)

VIEW IN SHOREHAM, L. I.

In 1934, the village added to its parklands a "buffer strip of land" just west of the village. R.L. Griffin, the owner of this home at the time, was a village trustee and was able to acquire most of the "buffer land" behind his home. (LB.)

COTTAGES IN SHOREHAM, L. I.

"It's a dream and I can't tell you how much I appreciate it," were the sentiments on this 1914 postcard. The home in the foreground was owned for many years by Francis W. Gridley. Barton Road was later changed to Gridley Road in his honor. Gridley was the village's first treasurer from 1913 until 1917 and later its mayor from 1920 until 1922. He later supervised the 1934 addition to the country club. His tennis court was a rallying place every weekend. Alfred W. Varian, owner in 1917 of the second home in the photograph, was a lawyer in the city as well as mayor, village trustee, and village attorney at many different times in the village's history. (MAO.)

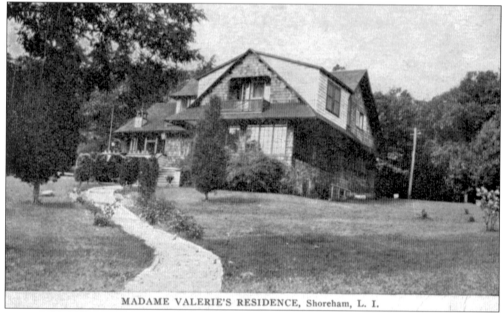

MADAME VALERIE'S RESIDENCE, Shoreham, L. I.

T.J. Smith owned Madame Valerie's residence on Barton Road in 1917. Originally bought from Hapgood's Oak Ridge Company in 1908 by Eliza W. Hurlbut of New York City, her husband, William Hurlbut, was a Broadway playwright and later a Hollywood screenwriter. Madame Valerie taught voice to Shoreham villagers Kathryn Kohlmann (Pallister) and Eugenie Finn (Madigan) at the Metropolitan Opera House in New York City in the late 1920s. (MAO.)

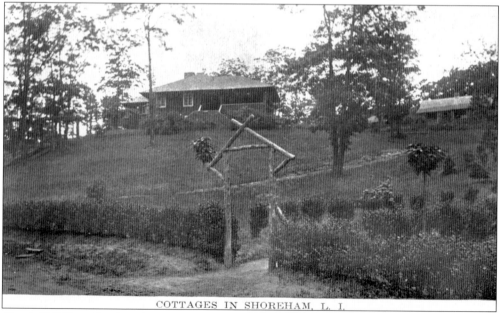

COTTAGES IN SHOREHAM, L. I.

Claude V. Pallister lived in this home on the corner of Holton Road and Oak Lane (now Beatty and Oliver Roads). He was the lawyer for the Village of Shoreham and handled its incorporation in 1913, after which he was elected as its first mayor, a position that was then called president. He directed the building of the concrete roads, whose financing necessitated incorporation. The home was later owned by the Clemente family. (LB.)

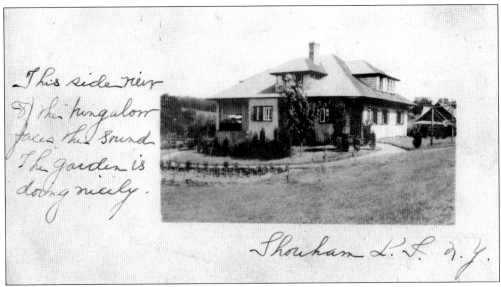

The writer of this postcard on July 23, 1912, reflects many written from Shoreham in its early years as a summer colony: "This side view of this bungalow faces the Sound. The garden is doing nicely. All goes well at Shoreham. It is delightful here and Lyles loves the water." This home is labeled "H.L. (Lyles) Zabriskie" on Perkins Street on the 1917 map. It was destroyed by fire in 1966. (LB.)

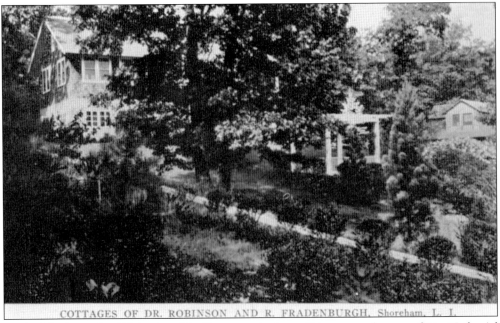

COTTAGES OF DR. ROBINSON AND R. FRADENBURGH, Shoreham, L. I.

Perched high on the hill in the old village are the beautiful summer homes of Dr. Nathaniel Robinson and R. Fradenburgh. Robinson purchased his home in 1908 and Fradenburgh in 1907 from Hapgood's Oak Ridge Company. Doctor Robinson served as the village's health officer and imposed infection control measures, including inspection of milk from the nearby Kraus farm after there was a case of infantile paralysis (polio) in the village in 1916. The Shoreham Store was forbidden from selling ice cream and soda water until the epidemic passed. (MAO.)

Shoreham has always been known for its beautiful flowering trees. This view looking up Sturgis Road (now Beatty Road) also shows the Shoreham Village's distinctive 1914 concrete roads with their pattern of black tar seams. Sentimental residents protested the blacktopping of the original roads in 1970. In the distance is the Tully Marshall house. (LB.)

A footpath, likely an old woodcutters' road, ran through the magnificent hardwood forest between Briarcliff and Woodville Roads roughly along modern-day Valley Way. It provided a shortcut for pedestrians between the railroad station and the Shoreham Inn and old village. (MAO.)

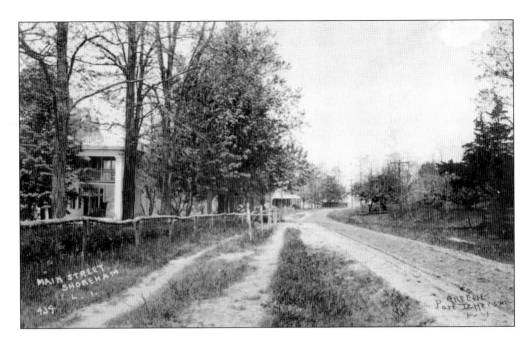

Pictured is Woodville Road looking north, called "Main Street" by photographer Arthur S. Greene. At left is Frances Upham Warden's home. In the distance is a small cottage (demolished in 2005) that in the 19th century had been, at different times, a store, tavern, chicken coop, carpenter's shop, sawmill, and fruit cellar, according to Randall Warden in the *Shoreham Scribe* on August 24, 1934. The Shoreham Country Club can be seen in the distance. The lower photograph, looking south, was taken after 1930 and shows the Warden residence, which had been converted to Shoreham's second hotel, the Maples, and later called the Dove and Turtle. (MAO and LB.)

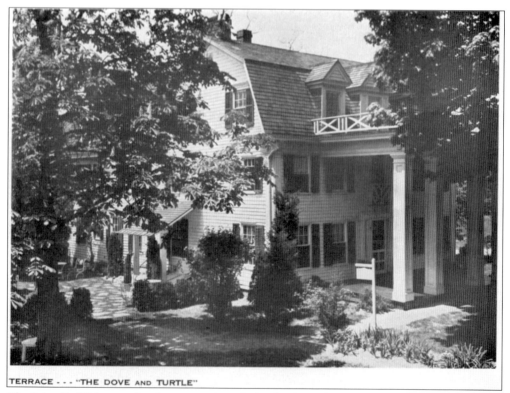

TERRACE - - - "THE DOVE AND TURTLE"

The John R. Dickerson farmhouse was bought in the 1890s by James S. Warden and run as the Maples Country Inn by his widow, Francis Upham Warden, until the 1930s, when it was taken over by two ladies from the city, Mrs. Ballinger and Mrs. Thorn. They remodeled and reopened it in 1937 as the upscale Dove and Turtle, which included two dining rooms and "one of the most unique, well stocked, and well run bars outside of New York City," according to the local paper. Famed children's author and illustrator Ludwig Bemelmans was, for a time, the barkeep and left some whimsical murals on the basement bar's walls, which unfortunately have faded over time. There were even live doves and turtles on the premises. It is now privately owned and lovingly restored as a wonderful family home. (SVA and KB.)

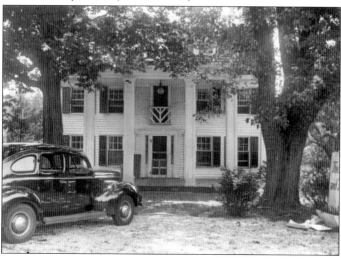

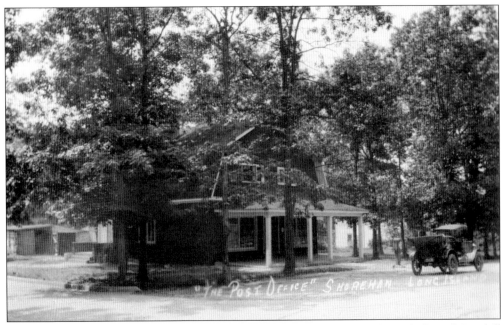

In 1910, Herbert Hapgood built this store and post office on the corner of Woodville and Overhill Roads to serve his new development. It replaced the previous store by the train station, which had been run by Margaret Brennan, which then become a Catholic chapel and is now a small professional building on the corner of Briarcliff and North Country Roads. Local entrepreneur and resident Jack Chapman became the postmaster and proprietor of the new store. In her written recollections, the late Mary McCarrick Ryan of Rocky Point remembered that as a child she would visit the store with her brothers and "there was always a group of men from the village that hung around the store discussing the weather, politics or their golf scores of the day." Jack Chapman had also opened a nine-hole golf course along Briarcliff Road. (MAO.)

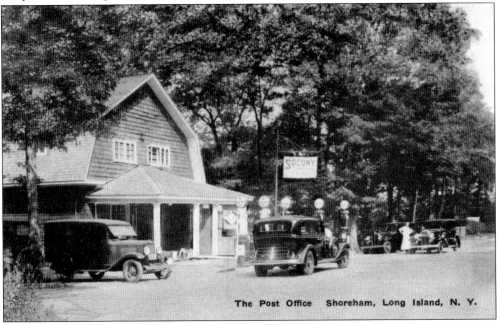

The Post Office Shoreham, Long Island, N. Y.

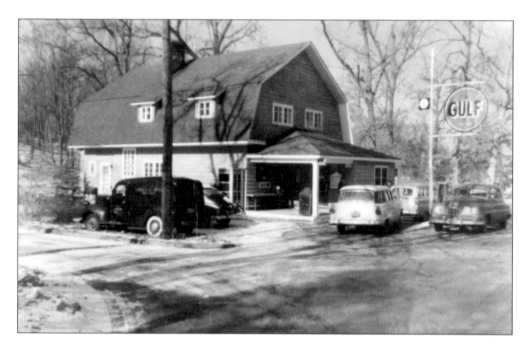

The Shoreham Store is pictured above in 1958 and below in 1983. The Shoreham Store ended its public history as a delicatessen and convenience store prior to its conversion to a private residence. The 1983 photograph below also shows that it briefly housed a hair salon. When it was a store, the owner often lived above on the second floor. The photograph below also shows the brick post office building, constructed in 1962. It is now a small professional building currently housing a doctor's office. (SVA.)

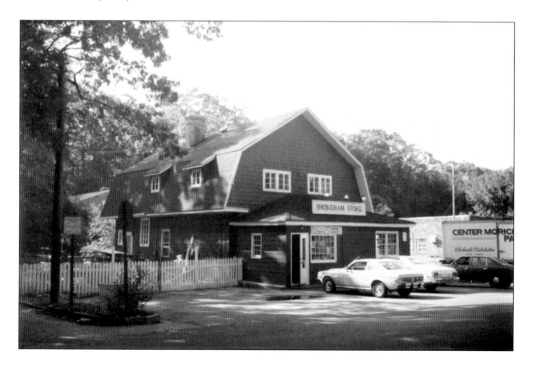

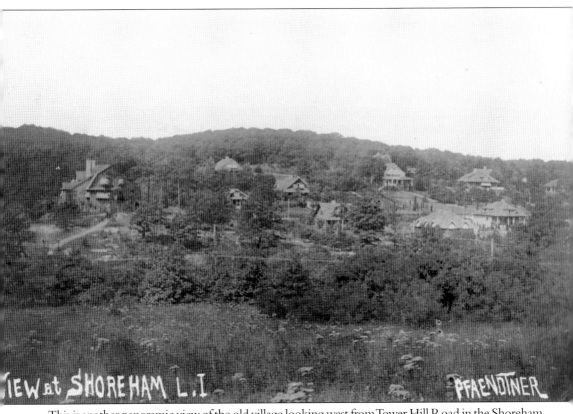

This is another panoramic view of the old village looking west from Tower Hill Road in the Shoreham Estates section. This remarkable view across the Woodville valley shows how open the country was at that time, thanks to farmers and woodcutters. This view is now obscured by trees. (LB.)

Seven

THE SHOREHAM ESTATES
GOLD COAST OUTPOST

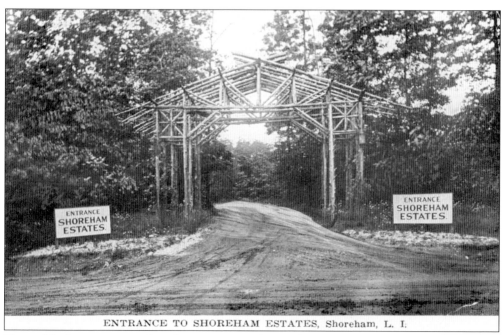

ENTRANCE TO SHOREHAM ESTATES, Shoreham, L. I.

Pictured is the entrance to Shoreham Estates on the north side of North Country Road at what is today Lower Cross. Then, it was the southern end of Briarcliff Road, marked by a locust log archway. Shoreham Estates referred to the dozen or so grand estate homes on large lots of five to ten acres. The homes were built along Briarcliff and Tower Hill Roads by Herbert Hapgood and his associates, Richard D. Upham and Henry B. Johnson, between 1908 and 1913. (JA.)

ROAD THROUGH SHOREHAM ESTATES, Shoreham, L. I.

This photograph shows the picturesque and heavily wooded Briarcliff Road as it ran north to the Shoreham Estates section. Briarcliff Road was originally a short farm road that ended at the Woodhull house, still standing just north of Suffolk Down. By 1900, Briarcliff extended to Sills Gully for access to the brick works that were then in operation. Soon thereafter, it was cut through along the water to its northern intersection with Woodville Road at the Shoreham Inn. (JA.)

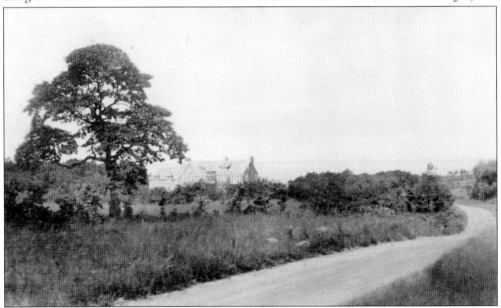

This sweeping view about halfway down Briarcliff Road shows how open the country was at the time. Jason Chapman, with little clearing, developed a nine-hole golf course that operated just east of Briarcliff Road in the early 1900s. For lack of trees, many Shoreham homes distant from the coast had water views. Seen to the left is the magnificent Ashley estate with the Long Island Sound in the distance. (MAO.)

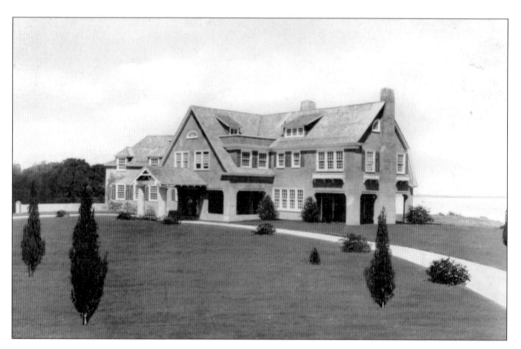

The Ashley estate was designed by architect John P. Benson and purchased in 1911 by attorney William Ashley. It was featured in the March 30, 1912, issue of *Town and Country* magazine, which noted, "the entire ground floor can be thrown open for entertainment." It remained in the Ashley family until it was sold to the Fuerderer family in 1963. George Fuerderer, a tinkerer and train buff, laid tracks and ran a scale model amusement park train around the extensive and beautifully landscaped grounds. The home in the background of the photograph below is the Callendar estate. Ivy Callendar Frei was the Shoreham Village historian from the 1950s to the 1970s. (MAO.)

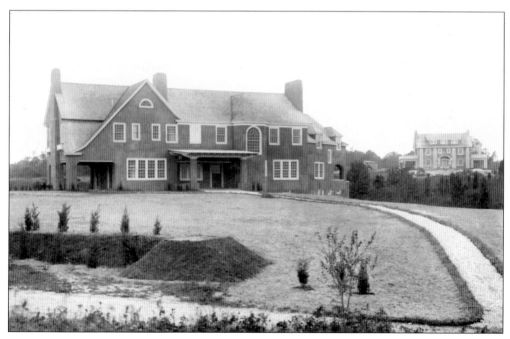

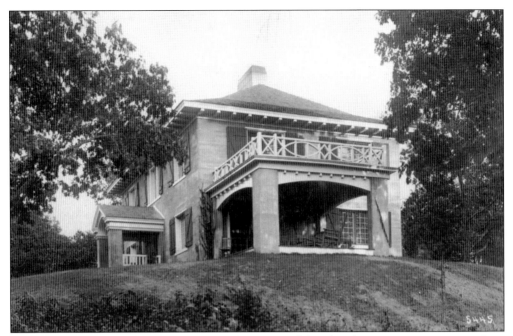

The hilltop estate of Richard D. Upham, a developer of the Shoreham Estates section, was later expanded by his son Donald in a Normandy style for his French bride. In the 1940s, it was converted to a French summer school, and in the 1950s, it became the Briarcliff Elementary School of the Shoreham School District, later Shoreham-Wading River. (JA.)

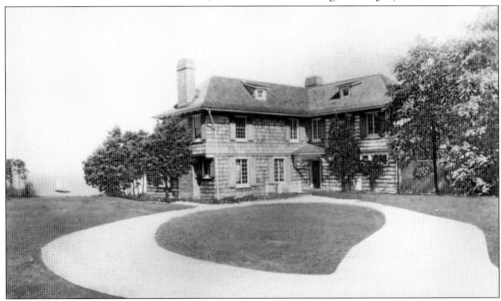

This is the distinctive L-shaped waterfront home of Henry B. Johnson, Esq., co-developer of the Shoreham Estates section. Although Herbert Hapgood had moved to Mountain Lakes, New Jersey, when most of the development of the Estates section took place, he remained in frequent communication with his partners concerning the activities in Shoreham. This home was later owned by the Hunsicker family and then the Schweyer family in the 1950s through 1970s. George Schweyer was a prominent attorney. (MAO.)

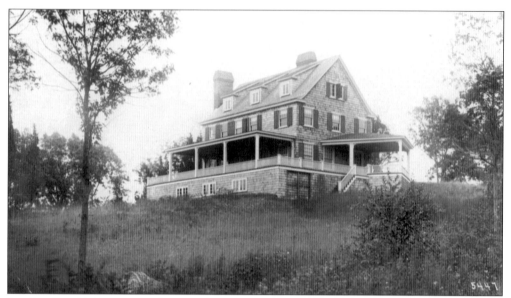

Dr. Caroline H. LeFevre, a physician, bought this hilltop home with more than three acres in the Shoreham Estates section in 1909 for $14,250 from the Suffolk County Land Company, the development company of Hapgood, Upham, and Johnson. She must have loved it here, for in 1950, she became very ill; after being hospitalized, she returned to Shoreham with her sister and Eunice Morgan Schenck, a friend, and passed away at the home in February 1951. Eunice, who inherited this home, was dean of the graduate school and a professor of French at Bryn Mawr College. (JA.)

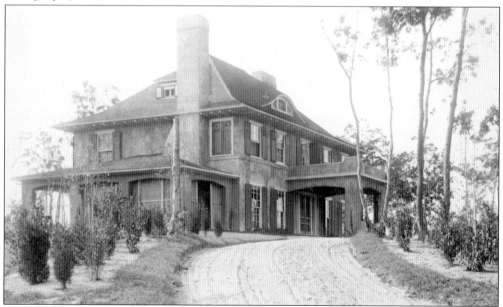

A visitor from Herbert Hapgood's other planned community, Mountain Lakes, New Jersey, would feel right at home in this stucco Franklin L. Gunther house at the high point of Tower Hill Road (see 1917 map). It shares many architectural elements, topography, and even a common street name with its "cousins," the grand estate homes of Mountain Lakes, nestled in the rolling hills and lakes of suburban northern New Jersey. (MAO.)

Nora Stanton Barney was the first female civil engineer to graduate from Cornell University. She designed and built this beautiful Tower Hill home for her mother, famous New York suffragist Harriot Stanton Blatch, daughter of women's suffrage leader Elizabeth Cady Stanton and president of the New York's Women's Political Union. In the summer of 1913, to celebrate a successful week of suffrage campaigning on eastern Long Island, Blatch hosted "Frolic at Shoreham," a big, lively outdoor celebration including water sports for which all of Shoreham turned out. Blatch's daughter Nora Stanton Barney was also a women's rights crusader as well as a successful architect and engineer. For a time, she was the wife of famed radio pioneer Lee De Forest. (CJ.)

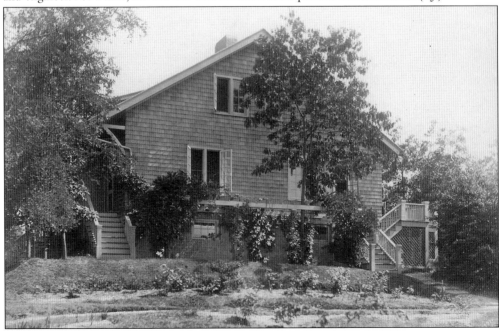

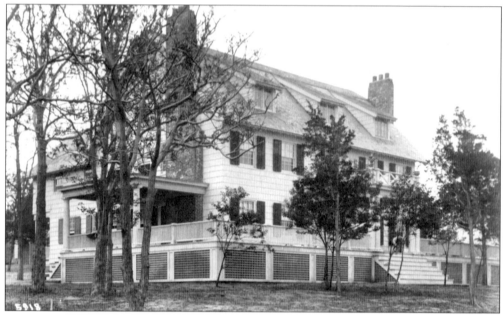

Along Briarcliff Road stands this stately waterfront home with a very distinctive roofline. Its first owner was Robert Carter, Esq. He bought this home in 1909 with two and three quarters acres of land from the Suffolk County Land Company for $9,000. Later owners included famous Yankees owner Dan Topping and, in the 1960s, Doctor Savoia and his family. An article in the April 23, 1911, *New York Herald* presents Shoreham, Long Island, as an "Exclusive Suffolk County Community," including pictures of several of the Shoreham Estates. The article lists some of its outstanding features, which included an unlimited supply of water from artesian wells, everyone owning property having permanent beach rights, and, incidentally, "the beach at Shoreham is as fine as can be found on the north shore . . . Three minutes walk from the property are the post office and a store in which supplies can be obtained." (JA and MAO.)

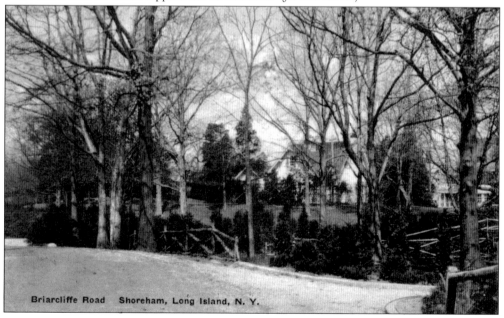

Briarcliffe Road Shoreham, Long Island, N. Y.

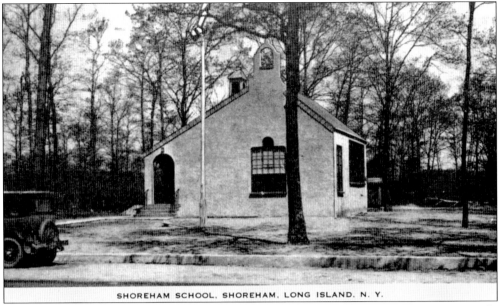

SHOREHAM SCHOOL, SHOREHAM, LONG ISLAND, N. Y.

This 1927 Spanish mission–style stucco schoolhouse on North Country Road east of Woodville is now a private business, having served as a one-room schoolhouse and then a kindergarten until the 1960s. It had been designed by architect Lewis Inglee of Amityville to replace Shoreham's prior schoolhouse, located farther east on North Country, which had been destroyed by fire on April 21, 1926. A modern-day photograph below shows the Briarcliff Elementary School, which was previously the Norman-style mansion of Richard D. Upham pictured on page 118. Around 1947, it was sold by the Upham family and repurposed as a school, first as the summer boarding school of the Lycée Francais de New York. In 1951, it was purchased by the Shoreham (now Shoreham-Wading River) School district and, after renovation and expansion, was converted into an elementary school and still serves that purpose today. (JA and MAO.)

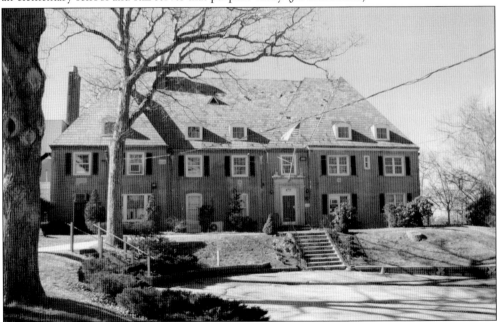

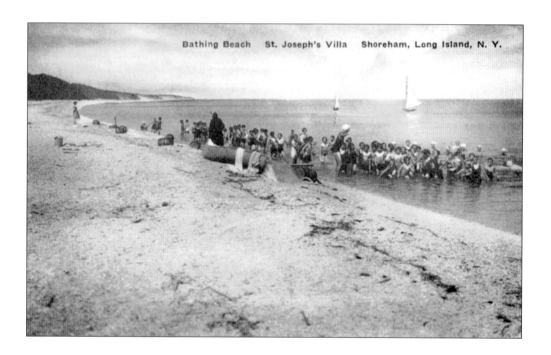

According to former campers, St. Joseph's Villa was a summer camp run by nuns and associated with St. Joseph's Hall in Brooklyn, an orphanage run by the Sisters of Charity. The villa in Shoreham stopped summer camp operations in the late 1980s, but the nuns would still return during the summer months for a retreat until the land was sold and the buildings were finally torn down in early 2001. (MAO.)

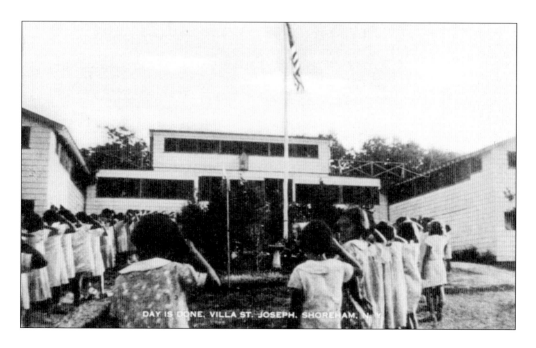

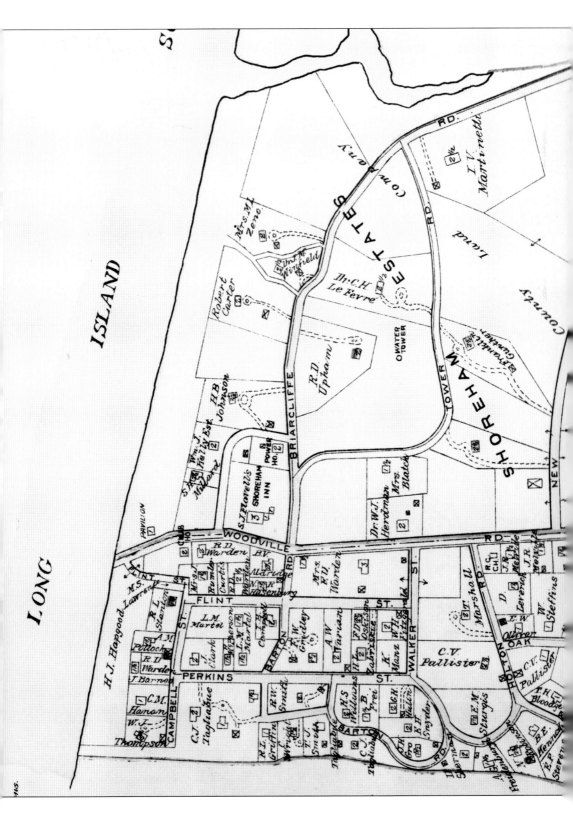

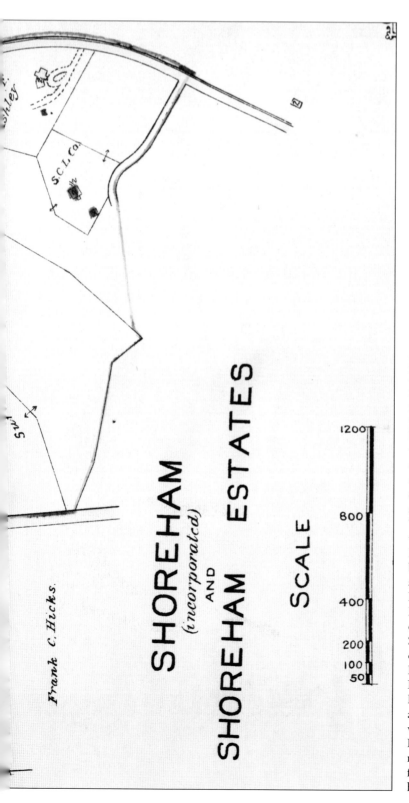

SHOREHAM
(incorporated)
AND
SHOREHAM ESTATES

SCALE

1200
800
400
200
100
50

Frank C. Hicks.

S.C.L. Co.

E. Belcher Hyde of Brooklyn illustrated the homes and homeowners of Shoreham and Shoreham Estates wonderfully on this 1917 map. One can find the location of many homes by owners' names referenced in individual home photographs in this book. The wonderful winding roads did not occur by chance but were the design of landscape architect Arthur T. Holton, who was a partner with Herbert J. Hapgood both in Shoreham and Mountain Lakes, New Jersey. Hapgood and Holton carried many of the Shoreham road names over to Mountain Lakes, including Briarcliff, Tower Hill, Hillcrest, Barton, and Dartmouth. On visiting Mountain Lakes, New Jersey, a native of Shoreham feels very much at home. (MAO.)

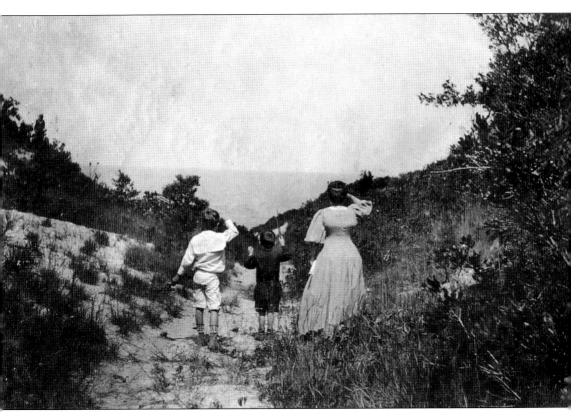

In Shoreham and Wading River, "go fly a kite" has always been less of an insult and more of a friendly suggestion for fun on a windy day by the sea. In this very early Shoreham photograph, Wesley and David Sherman and their mother, Ada (just a tad confined in a corset, then in fashion) take optimal advantage of the breeze funneling through the gully at Woodville Landing to keep their kite aloft. Shoreham and Wading River—then as now—are two beautiful little pearls strung along that thin line where land meets sea and where a grand and glorious past meets a future still brimming with promise. The photograph epitomizes the ageless themes of sand, sea, wind, protective parenthood, and exuberant youth. And it is also that ephemeral moment when the stuffy city dweller draws in a deep breath of fresh sea air and confronts for the first time the salty, sandy grandeur that is nature. (SVA.)

ABOUT THE ORGANIZATION

Wading River Historical Society has been the holder of the small village's history for over 65 years. Formed in 1947, the society had its initial meeting in the Wading River Congregational Church on January 5 of that year, where it was formally established and its constitution adopted. In the early 1950s, the society negotiated to acquire the home of Mary Raynor Howell for the purpose of housing the society. The deed to the property was presented on July 11, 1952. Believed to have been built around 1826, the house was owned by Frederick Hudson, Zophar Mills, Gabriel Mills, and other families until 1864, when Ebenezer Jones deeded it to Daniel B. Howell. It then became the home of Chauncey and Mary Raynor Howell. The society maintains the History House, which features local artifacts, farm tools, vintage clothing, historical documents, and books on local history and genealogy. It also hosts visits from school children and individuals by appointment.

Although Shoreham does not presently have a historical society, it has had a remarkable succession of great historians, most of whose writings can be viewed on the Shoreham Village website, www.shorehamvillage.org. The website has become a very open and accessible repository of written histories and historical maps and photographs, including the outstanding early-20th-century photographs of noted Port Jefferson photographer Arthur S. Greene. The online collection includes, as of this writing, Shoreham Village newspapers (1930–1945), which feature the writings of the village's first historian, Randall Warden, who came to Shoreham in 1894 and witnessed first-hand its founding by his father, James Warden. His writings depict the challenging early days when the village's unique character and institutions developed. The website also includes excellent histories by former Shoreham-Wading River principal Mary Lou Abata and Ivy Callender Frei, Shoreham Village historian from 1950 to 1972. The website also includes writings by Mervin Pallister, Shoreham Village historian 1972 to 1986, whose father, Claude, served as Shoreham's first president. Pallister's son-in-law Peter Spier was Shoreham Village's next historian from 1986 to 2010 and is the person responsible for building and organizing a meticulously well-preserved and well-documented Shoreham Village historical collection that the village's current historian, Dr. Mary Ann Oberdorf, has been able to share with the world through her other role as Shoreham Village's webmaster. Dr. Oberdorf welcomes the contributions of historic photographs, documents, and artifacts in hard copy or electronic format. She can be contacted through the Shoreham Village website. It is an exciting and historic time in Shoreham Village as it enters its centennial year of 2013! Share in the excitement!

DISCOVER THOUSANDS OF LOCAL HISTORY BOOKS FEATURING MILLIONS OF VINTAGE IMAGES

Arcadia Publishing, the leading local history publisher in the United States, is committed to making history accessible and meaningful through publishing books that celebrate and preserve the heritage of America's people and places.

Find more books like this at
www.arcadiapublishing.com

Search for your hometown history, your old stomping grounds, and even your favorite sports team.

Consistent with our mission to preserve history on a local level, this book was printed in South Carolina on American-made paper and manufactured entirely in the United States. Products carrying the accredited Forest Stewardship Council (FSC) label are printed on 100 percent FSC-certified paper.

MADE IN THE USA